To all those inspired individuals
who work so tirelessly – often against overwhelming odds –
for the welfare and conservation of animals,
this book is humbly dedicated.

Drawing and Painting
ANIMALS

Cécile Curtis

TO THE ZOO

NORTH LIGHT BOOKS Cincinnati, Ohio

By the same author:
The Art of Scratchboard, North Light Books, 1988

First published in North America 1990
Second North American Printing 1991
North Light Books
an imprint of F&W Publications
1507 Dana Avenue
Cincinnati Ohio 45207

ISBN 0-89134 352-0

Typeset by Servis Filmsetting Ltd, Manchester
and printed in Hong Kong

for the publishers
B.T. Batsford Ltd
4 Fitzhardinge Street
London W1H 0AH

CONTENTS

ACKNOWLEDGEMENTS

I should like to extend my sincere thanks to all those whose invaluable assistance has meant so much in the creation of this book, through the loan of material, permission to reproduce it, and making available their lovely pets as models.

I am deeply grateful for all the help offered by these kind people who are involved in the following charitable organizations: Bridget Tibbs of Deen City Farm in Mitcham for access to the animals on pp 83–86. Jimmy Feeney of The National Canine Defence League for the loan of the transparencies on pp 66, 72, 105 & 157. Vivienne O'Connor of The Royal Society for Nature Conservation for those on pp 31, 32, 96, 136–37 & 152.

Marjorie Unwin of Swan Lifeline for making me so welcome at her sanctuary pictured on pp 128–29 and also Kay Webb for the loan of the original on p 29.

I am indebted to the following publishers for permission to reproduce the work I did for them: Katy Bain of Educational Projects for the two on p 27 and five on pp 118–19 from 'The World of the Seaside'. Frank Fehmers of Frank Fehmers Productions, b.v., Amsterdam, for pp 24, 100, 122 & 134 from 'No Man's Valley', Vols I & II. Christina Foyle of Foyles Book Club for p 153 from 'Elephant Adventure' by Willard Price. Hodder & Stoughton for pp 95 & 150 from my book 'Woody's Wonderful World'.

Macdonald for p 146 from 'Thames Passport' by my husband, Roy Curtis. Frederick Muller for p 21 from 'African Valley' by R H Ferry. Frederick Warne for pp 107–8, 120 & 141 from my book, 'He Looks This Way'.

And to the art publishers: Rosenstiel for the print on p 147 and F J Warren for the prints and cards on pp 102, 106, 109, 111, 141 & 150.

Also, the following companies for supplying transparencies, information, and reproduction permission: Donald Everton of Erin Bleach ('Vista' towels) for the information and transparency on p 156. Trevor Dean of Image Promotion for pp 20, 68 & back jacket. Mason Supplies for p 19.

Robert Copeland of Royal Worcester Spode for pp 44–49, 52–56 & 133. Elizabeth Oxby of Winsor & Newton for pp 13, 26, 36, 38–39 & 43.

For the pet owners who have allowed me to reproduce their paintings and persuaded their animals to 'pose' for me, my thanks go to: Ray Ansell for 'Tom', p 75; Penny Boyd for 'Mrs Mac', p 83 and 'Ms Ralph', pp 92–93; the proprietor of the 'Cosy Café' for 'George', p 83; Janet Gillman for 'Emma', 'Scruffy' & 'Smartie' pp 34–35 & 77–78; Jane Glover for her friend's painting of swans, p 125; Betty Hall for 'Harry' p 83; Mr & Mrs Colin Higgs for their jolly foursome, pp 60–61; Mr & Mrs Brian Nicholas, with a special thanks to Doreen for her 'baker's dozen' of Old English Sheepdogs, pp 16, 62–63, 69 & 154; Mary Saunders for 'Ginger', p 77; Mr & Mrs Donald Sparkes for 'Penny & Sally', p 74; Elsie Vipond for 'The Best of Friends', p 81.

Once again, I am very grateful to my sister, Madeleine Fleitas for sending all those drawings that included pp 57 & 112–13, and to Dottie Sheffield for bringing them to London.

My thanks also to Louise Simpson of Batsford for her help and enthusiasm and to Jeanne Cook for her admirable patience, speed and accuracy in turning my manuscript into an immaculate typescript.

My acknowledgements would not be complete without another tribute to the patience and understanding of my mother-in-law, Emma Curtis, and my daughter Lisa over these past several months. I have missed them.

INTRODUCTION

Before it became too time-consuming, I used to travel up and down the country for a leading lecture agency, giving talks illustrated with a portable exhibition of my work. There was a choice of five titles listed in my brochure, of which the most popular by far was the one called 'Animals Through the Eyes of an Artist'. During the question time afterwards, I would inevitably be asked what was my favourite subject. I always replied, 'The one I'm working on at the moment'. Although this is basically true, of course there are some to whom I am particularly attracted; I shall leave it to the observant reader to discover which.

Certainly when one is really absorbed in the study of a species, it does tend, for the moment at least, to become the most fascinating. The same can be said for a particular medium or, indeed, a combination of two or more, if circumstances permit one to make just the right choice for a given subject. Some animals lend themselves to pen and ink or scraperboard, others demand colour in subtle or brilliant tones on white or tinted backgrounds and there are those which seem especially appropriate for sculpture. The artist strives to create a three-dimensional effect using only two dimensions or, when possible, a sense of movement in modelled figures, which is, of course, limited by the sheer mechanics of production.

A knowledge of the animal in question is very helpful when you are studying it and enables you to capture it more successfully in a chosen medium. For this reason, I have made passing references to such engrossing topics as symbiosis – the mutually beneficial relationship between widely differing species – as well as the recently expanded science of ethology – the analysis of animal behaviour. Included, too, is the principle of protective coloration, a knowledge of which will enable you to understand better what you see, and help you achieve a more perceptive interpretation. Although I have not attempted a detailed study of anatomy, it is useful to compare the structures of different species with our own.

Animals have been a source of inspiration for artists through the ages, as can be seen from the earliest cave paintings up to contemporary examples. Their infinite variety and universal appeal attract an ever-growing interest and enthusiasm. Their complexity presents a challenge to those who would capture them in form, line, tone or colour in a manner which even the best photographs often fail to convey. Many

Dutch garlic toad. Gouache. 137 × 265mm (6 × 11½in).

details can only be discerned by the closest proximity. Paradoxically, it is also true that the success of a drawing or painting sometimes depends on what is left out, as well as what is put in. Frequently, however, as in the case of elusive wildife – especially the rare species – photographs are all we have. There are also instances when it is the fleeting glimpse of a split-second movement that is necessary. In any case, several photographs are always better than one, as the camera can pick up confusing shadows and exaggerate perspective.

It is essential to be ever alert to the ideal position or angle, seeking, whenever possible, an originality of approach that best expresses an animal's nature. This requires intense dedication, sympathy combined with respect, and even a sense of wonder.

With these aims in mind, let us start out on an artistic safari to observe not only the exotic, wild varieties, but also the more familiar domesticated ones from whom we can learn so much.

MEDIA

DRAWING MATERIALS

SURFACES

There are many types of paper, board and canvas surfaces, sometimes referred to as 'supports', with which to experiment and to choose from. Sketching books or pads, come in many sizes with a choice of thicknesses of cartridge paper as well as texture, which is often divided into Rough, NOT and Hot Pressed (HP) categories; Rough is untreated with strong texture; NOT (Not Hot Pressed) is cold-rolled to leave some texture; and HP is very smooth. Some pads are spiral-bound and others are gummed along one edge. For outdoor work, the former are easier to handle, and the smaller sizes are usually more practical. Rough-textured paper, which is also manufactured in large sheets, is available in an

Pencil drawing using HB, 2B and 4B lead pencils on cartridge paper. 202 × 197mm (7⅞ × 7¾in).

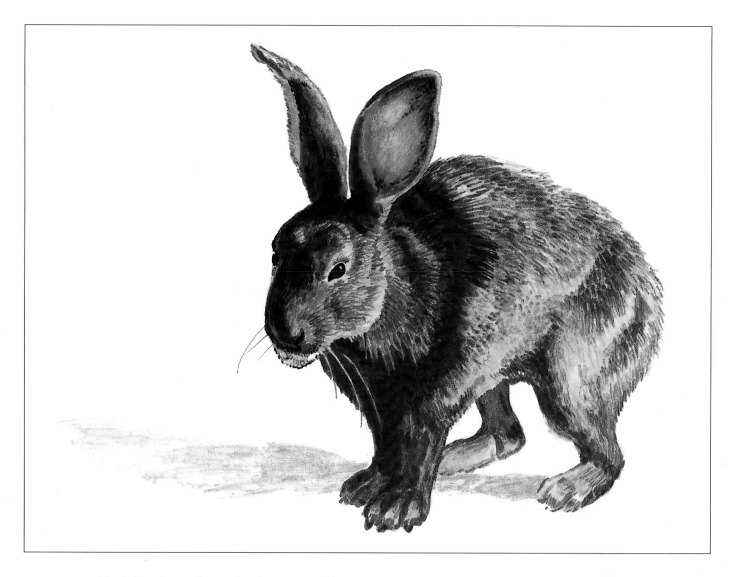

assortment of both bright and pastel colours as well as white, and is very effective for black and white or coloured drawing and painting media, as will be seen.

Illustration board is made in rough and smooth finishes too, and mounting board comes in a wide range of subtle tints and bright colours, although this is not textured.

Canvases can be purchased not only in the traditional version on stretchers, but also in pad form with gummed edges. There are even rough- or smooth-grained oil painting papers in addition to the more familiar canvas boards.

Colour sketch done entirely with conventional felt-tip pens on HP *surface colour wash paper. 117 × 152mm (5 × 6½in).*

Watercolour papers are generally available in pad form too, as well as individual sheets in various weights and textures. Of course watercolour may be used on illustration and mounting boards, especially when mixed media is involved, although it is best on a white, textured surface.

PENCILS, PASTELS AND PENS

I usually use black-lead pencils for quick sketches, preliminary drawings and layouts, which come in varying degrees of hardness or softness. Hard pencils are marked from 7 H (the hardest) to H and soft ones, which are more commonly used by artists, are graded: HB, B, 2B up to 8B, which is the softest and blackest. I usually start with an HB, shading with a 2B and putting in the stronger accentuations with a 4 or 5B to avoid too much smearing. Coloured pencils come in a great variety of shades and the darker colours are excellent for sketching as well, but one can also achieve a very finished effect with fine detail and subtleties of shading as demonstrated in the illustration of the California Condor. This shows their versatility on a rough texture with the variation of a pale tone applied on top and worked in to produce a softer look where appropriate. Chinagraph pencils, which are meant for use on smooth, polished surfaces, are an interesting addition to one's repertoire of materials; you can emulate the character of an oil painting when using the side of the lead on textured papers, especially those that are tinted. As chinagraphs are made of a wax-like substance, they cannot smear, but remember also that neither can they be erased! There is a limited choice of six colours, of which black, white and brown are the most useful for animal subjects. There are also watercolour pencils, which you can wash over after applying them to paper or board.

Conté crayons in black, white, sepia and sanguine, and pastels in bright, clear colours or alternatively, pastel pencils which are easier to handle, are favoured by many artists, but these must all be sprayed with fixative afterwards to protect them. Some people prefer oil pastels because they don't require fixative.

Ink provides a more permanent record, and there are many interesting types of pen available. You can use conventional nibs of varying widths in holders as well as technical pens, with graded points or variants, which give a constant thickness of line and have a built-in ink supply ideal for fieldwork. Felt- and fibre-tipped pens are also convenient for quick colour sketches, such as the example of the rabbit on the preceding page, as well as for layouts and in combination with other media. An exciting recent innovation are the *Pantone*, broad-nibbed, felt-tipped pens. These come in an astonishing range of colours, including a wide gradation of pale, subtle tones, most of which are also included in fine (F) and ultra-fine (UF) nibs.

When applying them to a thin surface, you must place two layers of blotting or tracing paper underneath it beforehand, otherwise the ink will instantly penetrate to the next page, or whatever is beneath it. The colours tend to spread, or bleed, slightly although this can be used to good advantage, and the few limitations are more than outweighed by

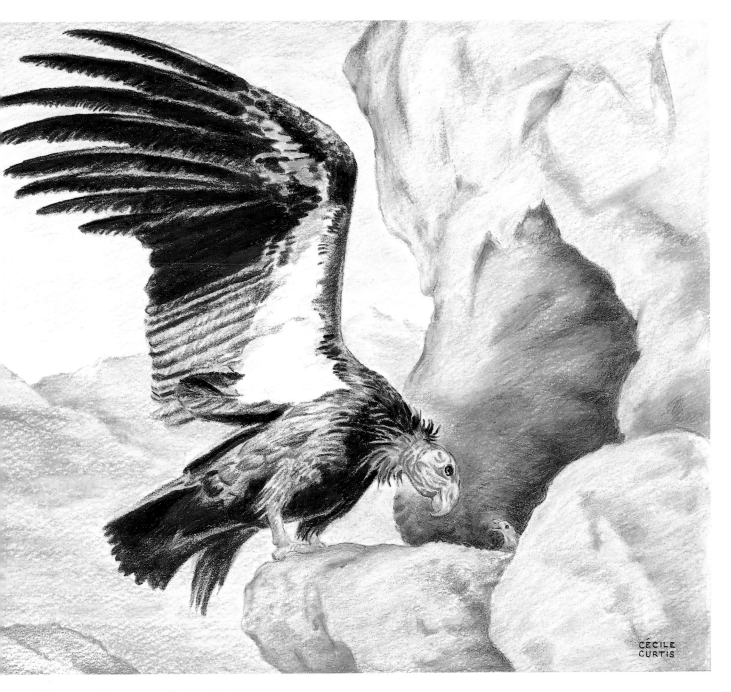

California Condor, rarest of birds and with the largest wing area, is poised on the very edge of extinction. Coloured pencil used throughout on heavy, rough-textured illustration board. Sky and mountains were filled in with the side of the lead, while the rocks and areas in background adjacent to the condor were softened by working over them thoroughly with pale grey. The chick is intended to be barely discernible as it would appear in its habitat. $178 \times 317mm$ ($7 \times 12\frac{1}{2}in$).

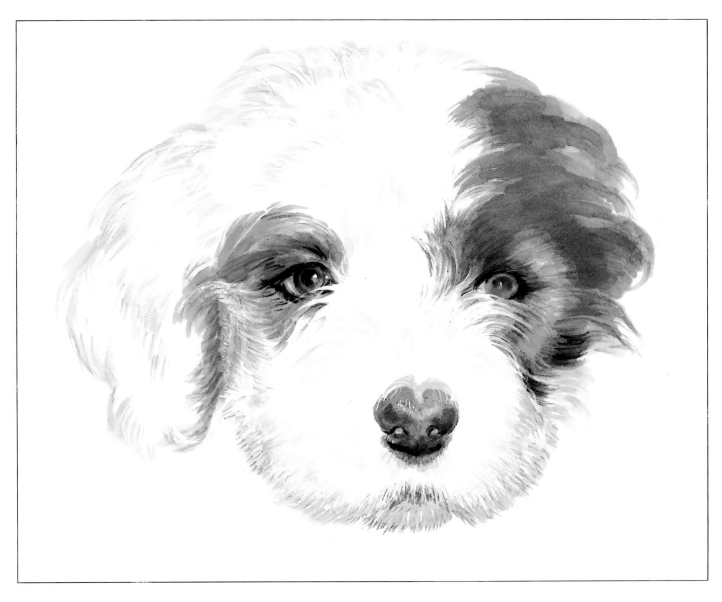

Study of an Old English Sheepdog puppy in four colours and black, employing only broad-nibbed 'marker' pens on HP surface colour wash paper. 160 × 195mm (6¾ × 7⅝in).

the finished results. The colours are not only permanent and waterproof, but they give a completely even, matt finish and are easily portable as well. In addition, they possess a unique property in combination with white, opaque watercolour paint. When applied over the top of a picture, any white paint remains intact, being impervious to the ink. Using the Pantone pens over white, you can thus leave delicate white hairs, for example, which would be difficult, if not impossible, to paint around if further emphasis were required. A typical instance can be seen in the head of this Old English Sheepdog puppy. The disadvantages are few, namely, that the top must be replaced immediately after every time each pen is

used, as they can dry out very rapidly. They also have a very strong odour, rather like dry cleaning fluid, so it is advisable to use them in a well-ventilated room.

Another version of these is the brush pen, a versatile adjunct to other media as well as being useful on its own. Brush pens are available in a dozen colours, which include three shades of both grey and brown, so necessary for portraying animals.

BLACK AND WHITE LINE

BRUSH AND INK

Black and white line provides the cheapest form of art work for reproduction. Of the many different techniques, the striking simplicity of brush and ink is certainly the one which presents the least difficulty in producing a faithful copy from the original. This chimpanzee was designed to be printed on tea towels and articles of clothing where fine lines would be inclined to disappear. Contrary to the usual practice of reducing a drawing, it was necessary to enlarge it for the towel and print it the same size as the original for the smaller items.

This technique can also serve as a useful lesson which I recommend for an exercise in achieving bold effects with a disciplined expression of form.

Try doing a pencil drawing of a subject in bright sunlight with shadows lightly indicated in outline only. Then with a brush, fill in the shaded parts in solid black, except for necessary definitions of eyes or jawline where small, descriptive white areas must be left. A few black lines and carefully positioned dots will give form to the lighted side.

Chimpanzee, brush and ink drawing for reproduction on linen for zoo souvenirs. It was enlarged to nearly twice the size of the original. 228 × 183mm (9 × 7¼in).

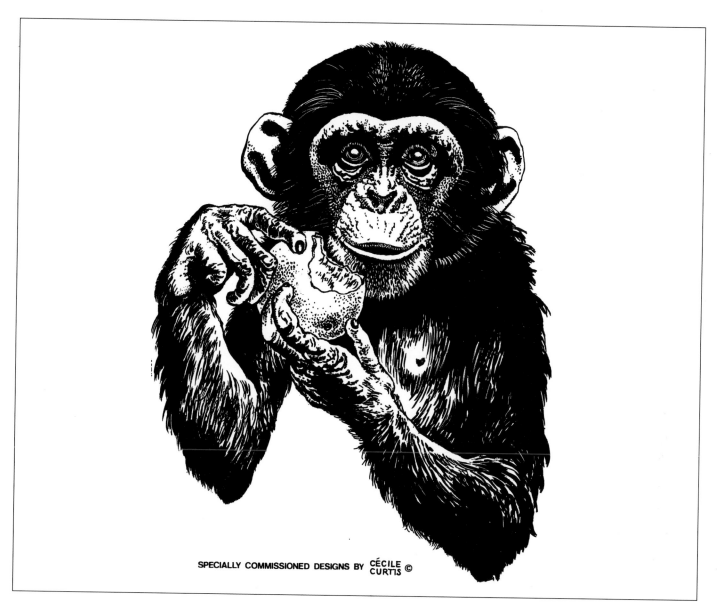

SPECIALLY COMMISSIONED DESIGNS BY CÉCILE © CURTIS

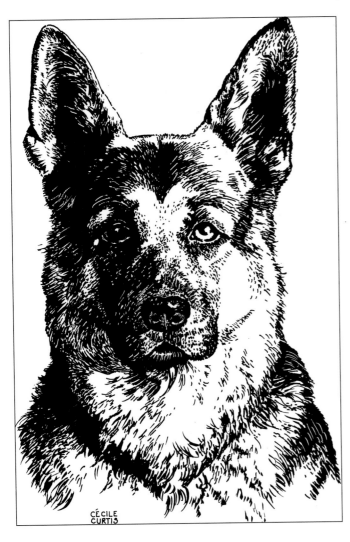

German Shepherd Dog, design for a T-shirt. Brush and ink combined with a No. 4 technical pen. 270×180mm ($10\frac{5}{8} \times 7\frac{1}{8}$in).

The portrait of the German Shepherd is a slightly more refined version of this same technique where the fur on the right-hand side and around the nose is enhanced with a thick pen point. It was reproduced on polyester in the size of the original using a sublimation print method, which retains the design in the material despite repeated washings. It is shown here reduced to less than half its size.

SCRAPERBOARD/SCRATCHBOARD

Scraperboard or scratchboard is stiff card coated with a thin layer of hardened china clay. It is manufactured in black or white, the former being more familiar to art students. The example shown on the right was done with special engraving tools and its similarity to wood engraving techniques is obvious,

the black being scraped, or scratched out, in varying degrees to produce light, texture and form. Both white and black card require a careful preliminary drawing, but for black, subtle shading is not so essential. Scraperboard/scratchboard must first be mounted on more substantial cardboard as it is very fragile and if bent, will easily crack. Having cut a suitable board the same size or slightly larger than one wishes to use, bind them together with a spray adhesive (such as those used for mounting photographs). Ensure that the surrounding area of half a metre (2ft) on all sides is protected by newspaper whilst spraying. After following instructions on the container, press the two boards together with a clean sheet of paper on top to avoid marking the scraperboard.

Your drawing must be traced, and after covering all lines on the reverse side with white chalk, or better still, pastel pencil, transfer them to the black board with a thin, white sheet between it and the tracing so that the lines are visible as you follow them with a red ball-point pen or well-sharpened pencil. You then have a soft, white replica of your design ready to scrape out with a series of lines, dots and areas of solid white. As the work progresses, you can wipe away the traces of chalk or pastel with your finger. It is best to begin at the bottom of the picture and work upward so as not to smudge the faint impression. Various tools can be used such as surgical scalpels, stencil cutters or any small knife with a very sharp point which should be maintained with an oil stone. A special instrument, also used for wood engraving, is a multiple tool that cuts several parallel, fine lines together. You can see a similar effect on the rays of light in the engraving of the lions. The lower one is just about the full width of the tool in this reproduction but was actually cut with a scriber, a single sharp point in a holder, together with the aid of a ruler. The brighter light at the top of the rays is the result of cutting twice in the same place. At the lower end, they were darkened afterwards with a No. 1 variant technical pen.

Working on white board involves an additional stage in transferring your design. After tracing the preliminary, 'working' drawing, having filled in the outlines to be shaded, transfer it by using black carbon paper. Once you have obtained an outline on the white board that includes those areas in shadow, ink it in using a pen and brush. Much of these shaded areas will be solid black so you need to reverse the tracing and apply white to the parts *within* the shadows that will require scraping out in varying degrees. This can then be transferred in the same

Lioness and cub in den. Book illustration on black scraperboard/ scratchboard, an ideal subject for this media (see The Art of Scraperboard Engraving, *Cécile Curtis, Batsford, 1988.) Its resemblance to wood engraving is more apparent than work done on white board. The texture of fur is particularly suited to either black or white and, with patience, a great deal of detail can be conveyed. 297 × 197mm (11¾ × 7¾in).*

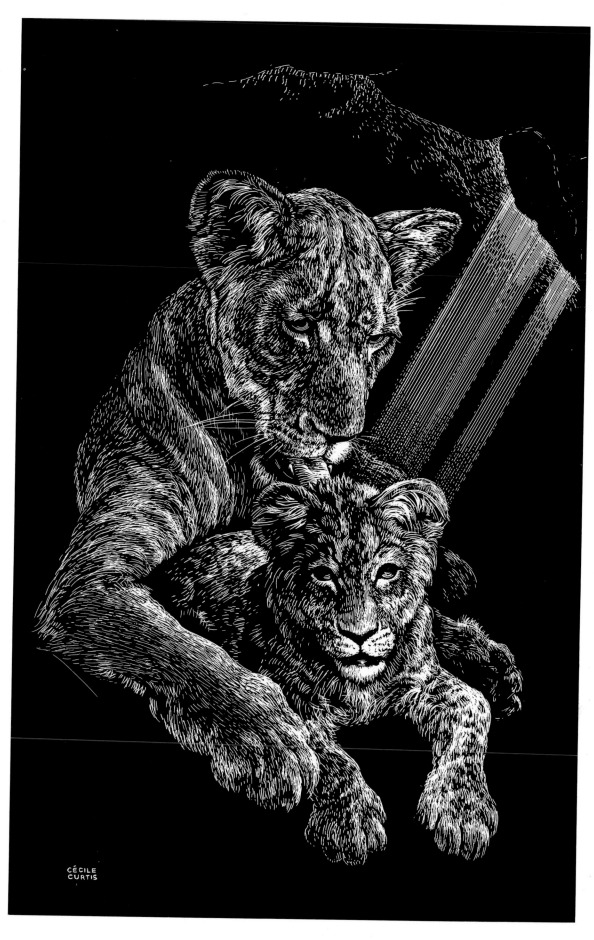

THE CHEETAH IS FOUND ON OPEN PLAINS IN AFRICA & IRAN WHERE ITS NUMBERS ARE EVER DIMINISHING.

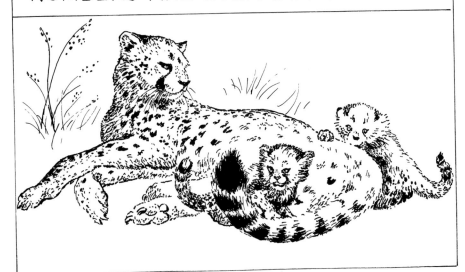

UNUSUAL FEATURES ARE ITS RANGY BUILD, NON-RETRACTILE CLAWS & STRIKING FACIAL MARKINGS.

manner as was the entire design on black. An advantage is that you will be able to refine the light areas with subtle variation of texture and tone, using a pen or fine brush, thus incorporating the techniques of engraving and pen and ink drawing in one.

Although scraperboard/scratchboard owes much of its development to wood engraving, it offers a good deal more freedom, not only because lines can easily be cut into a microscopically thin layer of ink as compared with engraving on a hard piece of wood, but also because it is possible to work up to virtually any size you wish without needing to do it as a reverse image from which a print must be made. If a vignette style or large white areas are preferable, they need not be scraped out when using white board. Examples of these can be seen further on in the book.

PEN AND INK

The above series of 'strip' drawings were done expressly for newsprint where little reduction is either necessary or desirable and where speed is also a factor.

This traditional medium can be either a means for quick sketching or way of achieving quite delicate effects in a more finished type of work. It is universally popular for illustrating newspapers, magazines and books where neither the quality of paper nor the expenditure on reproductions are very high. As such, it is an ideal medium for an aspiring illustrator. Far better to have several original and competent pen and ink drawings in one's portfolio, than overload it with ambitious colour work, which is rarely entrusted to a beginner. Remember too that good line drawings cost no more to reproduce than inferior work.

Pen and ink is far more versatile than one might suppose as, even with a technical nib of uniform thickness of line, one can do so much, merely using dots, dashes and uneven patterns without having to resort to the rather dated style which cross-hatching suggests.

FASTEST OF ALL QUADRUPEDS, IT HAS BEEN CLOCKED AT 70 M.P.H. IN SHORT SPRINTS.

Wildlife strip. Pen and ink on fashion plate board, HP surface. I used a simplified technique on one of the whitest illustration boards to give a clean, sharp image for reproduction on newsprint. 112 × 381mm (4 × 15in).

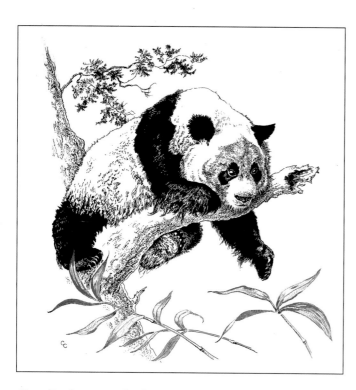

Giant Panda, pen and ink on fashion plate board, HP surface. Reproduction greatly reduced from 320 × 280mm (12⅝ × 11in).

The illustration of the giant panda in a tree shows how one can differentiate between its fur and the bark of the tree. The latter is expressed with a gradation of dots or, 'stipple' effect, while lines in the white fur simply follow direction of growth. The black parts were mainly filled in with a brush, leaving small areas which were worked into with the pen. The bamboo leaves in the foreground have been outlined in ink with a few accents inside and the rest of the shaded areas filled in with grey, which was only added as all the line drawings in this book had to include grey. As the illustration was to be printed on good quality, 'coated stock', I was able to make the original nearly four times the size of the reproduction, which gave more scope for technique.

The painting on the facing page shows the same subject matter handled in an entirely different way for a book on rare species of wildlife with younger readers in mind. There is not so much detail and the style is more decorative and very colourful. I chose a nearly identical pose for the amusing aspect of this rotund panda, who is not *quite* able to reach the tempting meal of fresh bamboo leaves!

The distinction between a good, representational picture and one which also has instant appeal, often depends on the ability to strike the right note of humour or pathos, whilst being true to the animal's nature and avoiding sentimentality. When possible, a thorough study of the subject in question can be very rewarding in this respect.

Giant Panda opposite, gouache on the same surface. 253 × 173mm (10 × 6¾in).

GOUACHE AND
WATERCOLOUR

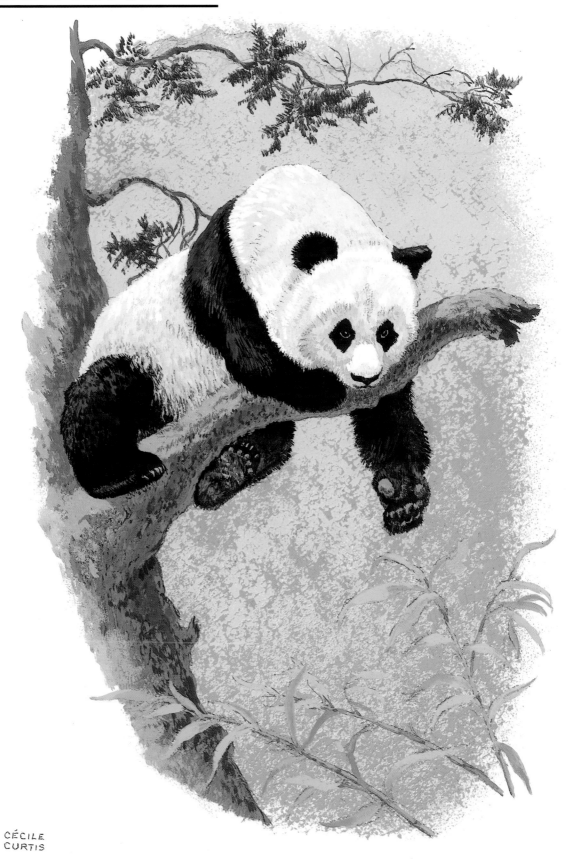

CÉCILE
CURTIS

The term 'gouache', which may be unfamiliar to some, is the French word for opaque watercolour that contains a high pigment content bound with gum arabic. It is one of the most popular mediums and has been in use for many centuries. Honey was once used as a binder, which may have caused some difficulty when working in the vicinity of bees!

The best quality for both opacity and stronger colour is 'Designers' Gouache', which offers a dazzling choice of 120 shades, each with coded letters indicating degrees of permanency, staining tendency and opacity.

In selecting from a chart, the wide range available can be somewhat confusing. Therefore I offer the following list which is quite comprehensive, although you may prefer to start off with a more limited selection and add even more to it as you gain experience.

Cadmium Lemon	Brilliant Red/Violet
Cadmium Yellow Deep	Brilliant Violet
Yellow Ochre	Ultramarine Deep
Raw Umber	Cobalt Blue
Vandyke Brown	Turquoise Blue
Burnt Sienna	Viridian
Red Ochre	Brilliant Green
Cadmium Orange	Linden Green
Primary Red	Olive Green
Alizarin Crimson	Ivory Black

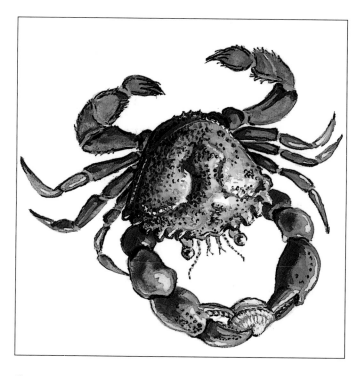

Shore Crab. 65mm (3⅝in) square.

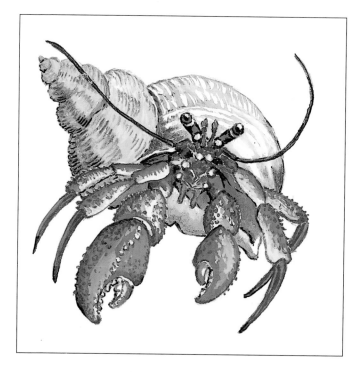

Hermit Crab. 65mm (3⅝in) square.

In addition, you will need Zinc White in a large-sized tube or, better still, Laser White or *Flo-2* opaque watercolour, which both come in jars. They are the purest whites and mix well with colour.

Palettes are made in plastic, polystyrene and porcelain. I personally prefer the latter, which is more expensive, but it is worth getting the best as these items will last. The type that has six wells and slants is the most practical. To complete your supply of equipment, an assortment of brushes made from either nylon or the more costly red sable should include a No.1 as the smallest, and Nos 3, 5 and 7.

WORKING ON WHITE BOARD

After a little practice, you will begin to appreciate how easy it is to attain great detail in this medium, traditionally used for painting miniatures. It can be applied in thin washes as with watercolour, and then painted over opaquely where appropriate, even when working on a very small scale. The two examples on this page are reproduced in the same size as the originals. Gouache offers enormous versatility for many styles, and you can even paint over a really solid application of colour when dry with touches of

thick, pure colour from the tube using a practically dry brush. The picture of the Giant Panda on page 25 at the beginning of this chapter shows another variation of techniques. The pink background was filled in first with a small, fine-grained sponge and the blue and turquoise added with a coarser one on top. After drawing the animal and vegetation over it, I completed the rest of the painting using a minimal amount of water in the brushes – just sufficient to allow the paint to flow.

When starting work, place only small amounts of paint in the wells of the palette, which should be just slightly wet. Only select colours you intend to use immediately, adding others as the need arises, because it is extremely difficult to use dried-up paint opaquely, especially when applying one on top of another. If any are to be left, even for a short time, cover them with a little water from a medicine dropper. Remove the excess later with paper towelling and if necessary, stir the remainder with the handle of an old paint brush or something similar, wiping it afterwards with a damp cloth. If left overnight, the palette should also be securely covered with a plastic bag or film.

COLOUR LINE ON TINTED BOARD

Mounting board is produced in a variety of colours and provides a most appropriate surface for gouache, which, when applied opaquely, creates an amazingly three-dimensional effect. Of course, subtler tones make the best backgrounds, and there is a fair choice of these.

Given a limited range of colours with which to create a design for line reproduction (which only records solid lines not tones), the tinted board is especially useful. The painting opposite was done with just two colours in addition to the grey-green background, plus black and white.

I was asked to design a tea-towel for a swan sanctuary entitled 'Swans of the World', which featured eight different sorts of bird. I did not want to make merely a field-guide representation showing them uniformly in rows, and it was important that the Mute Swan be more prominent than the others. I placed her in the foreground with the rest swimming back at a distance or in various stages of take-off and flight overhead. I had to allow space in the composition for the title and logo of the organization as well as information about each of the species, all of which were to be added on an overlay afterwards.

I left the colour of the board to form much of the shading, using pen and ink for some of the finest black lines, the rest being put in with a brush. The white had to be applied thickly to make it solid enough for a clear line reproduction, but a delicate touch was also required for detail of feathers and reeds. I used *FLO-2*, which goes on smoothly without showing brush marks, adding just a bit of water to the brush to make it flow sufficiently.

Some refinements and adjustments were necessary afterwards. For this purpose, I made up a colour which matched the grey-green, keeping it in a small, lidded jar so that it would not dry out. When it was left for a while, a vigorous shaking restored its original consistency, and I was also able to use it for defining white plumage where pen lines would have seemed too harsh.

The final effect in this example amply demonstrates the way in which subjects can stand out from a tinted background.

Some of the characteristics that typify the different breeds are difficult to distinguish and a good deal of careful research had to be done. I spent time looking through animal and bird encyclopaedias, wildlife magazines and field-guide books, but things were complicated by the fact that not all of these completely agreed with each other! This is often the case when researching a natural history subject, but eventually I gathered a consensus of information, and the result is shown here.

Starting at the upper left and going around clockwise, they are: the Whooper from Scandinavia; the North American Trumpeter; the Black-necked Swan from South America; the Whistling, another from North America; the Australian Black; the Mute, which is the most familiar, originating in both Europe and Asia; the Bewick's Swan from Northern Russia; and last, the smallest of all, the duck-like Coscoroba, also from South America.

Swans of the World. *Gouache with pen and ink on tinted mounting board. Design for a tea towel which was reproduced in the same size as the original artwork. 677 × 460mm (27 × 16in).*

FULL COLOUR ON TINTED BOARD

Gouache is a highly versatile medium that can be used in the same manner as watercolour or applied opaquely, even on some occasions, almost as thickly as oil paint where particular emphasis is desirable. Whether using white or tinted board, start with thin washes of colour. Remember, however, that it is much easier to darken rather than lighten these when overpainting. If it is necessary to apply light on top of dark, allow the paint to dry in order not to pick up the colour underneath. This is when sheets of paper towelling are also useful. Having mixed your colour, a gentle pressure on the paper to get rid of excess water and another dip into the mixture will permit a fairly positive covering. Remember that it will almost always dry darker, so further applications may be needed later when the area has dried completely. Of course, this is not so much of a problem when painting with pure colour straight from the tube.

CHOOSING THE BACKGROUND COLOUR

When choosing a coloured board, you should either use that which is closest to your subject's predominating colour, or else one which offers a real contrast. In the case of the former, you should have some rough idea before starting the drawing of where to put the background colour. Sketch the subject in lightly but accurately using coloured pencils and, as in this instance, a white pastel pencil, which is ideal on tinted board and easily corrected with the touch of a fingertip. Any unwanted traces will disappear completely when erased in the usual manner. By this stage, you should have decided where to leave the ground colour. The example on blue board indicates the strong influence of the basic blue, although it shows only in small areas. As there was a large proportion of background sky and blue plumage, the board colour was obviously the most desirable choice.

PLANNING THE COMPOSITION

With so many different elements in the painting to consider, I first did a fairly comprehensive preliminary drawing, or 'rough' as it is called, to decide which area would be most suitable for each bird. As I had decided to depict their relative sizes to each other, I placed them on virtually the same plane, avoiding any great distance between them. This sketch was done about one half the size of the finished painting using

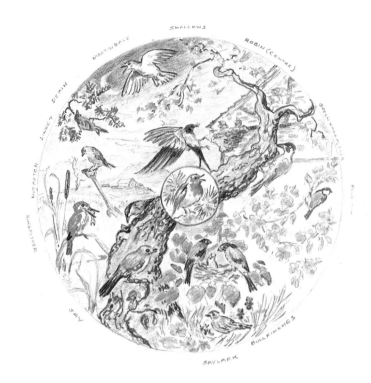

Initial drawing based on client's requests. The robin was omitted later.

coloured pencils and felt-nibbed pens, which are excellent for indicating bright colours on a small scale very quickly. I divided the circle into eight equal segments on a tracing paper overlay and then pencilled in the same lines very lightly on the blue board in order to enlarge the design up to the size of the finished work.

TECHNIQUE

As the painting progresses from cautiously blocked-in tones indicating shaded or darker parts and builds up to the full strength of positively placed light or darkly accented areas and sharply defined details, you suddenly appreciate the benefit of coloured ground – the subject literally seems to stand out in a most exciting manner!

Paintings I design for jigsaw puzzles have special requirements and are obviously more suitable if there are no large, unbroken areas. The composition needs to be 'busy' with something going on everywhere within its framework. It is advisable to employ as much contrast as possible. Where more subtle colouring is required, one must keep outlines distinct. I was asked to utilize at least ten different species of the more familiar wild birds and managed to include a dozen. The smaller or less conspicuous of these had to

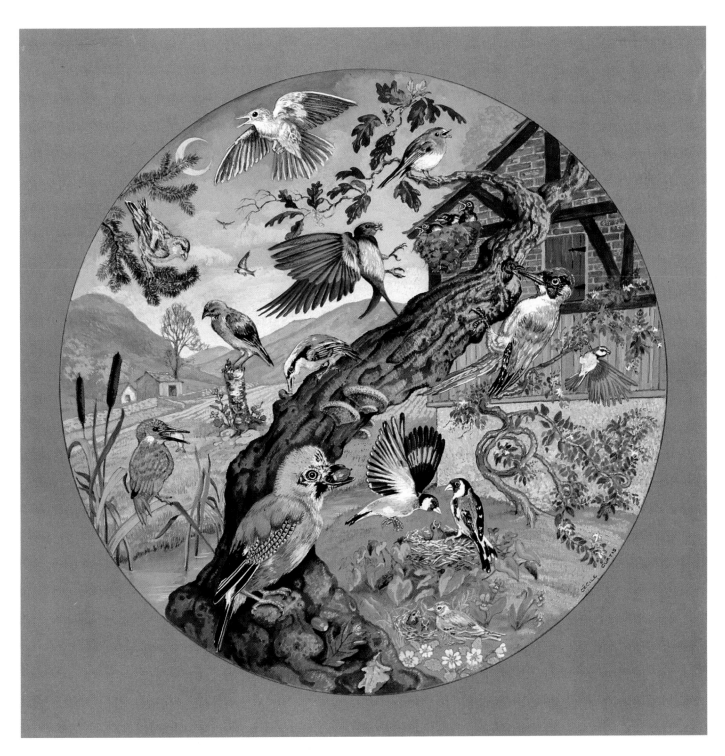

Wild birds, design for circular jigsaw puzzle painted in gouache on blue mounting board 380mm (15in) in diameter. It was printed in the same size as the original with a white border which indicated the types of birds. Starting with swallow (upper centre) and moving clockwise: robin, green woodpecker, blue tit, skylark, goldfinch (lower centre), jay, kingfisher, nuthatch, linnet (left centre), siskin and nightingale. As nearly as possible, the birds are depicted in their relative sizes to one another against a background which, in most instances at least, suggests the characteristics of their habitat. As jigsaw puzzle enthusiasts will appreciate, there are no large expanses of one colour, which would have made it far too difficult to complete.

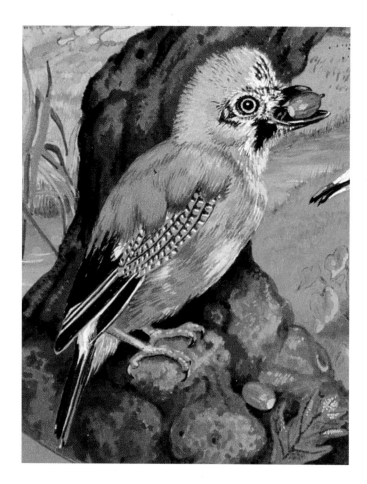

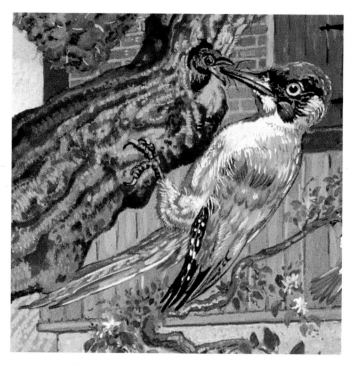

Detail of jay and green woodpecker, reduced by about two-thirds their size in the original painting.

be placed in a setting of strong contrasts, either in colour or tonal value. I solved the problem presented by the grey-blue of the swallow's wings against the sky by introducing a much paler tone, working into a pinkish-white near the horizon, which also served to outline the mountains in which the background colour predominated and where, at this point, the tail feathers are almost black. Down on the grass where the ground-nesting skylark appears, bright flowers call attention to and provide interest around this drably coloured bird. The jay, largest of all, shows up well against the slight suggestion of moss on the bark of the oak tree, the soft orange-pink tones of its feathers giving a subtle contrast to the greenish-brown, which, in turn, had to stand out from the brightness of the stream and fields beyond. The pale nightingale holds its own in a sky gradually deepened to create a nocturnal mood, defining the outline of a new moon.

The illusion of three dimensions is created by having well planned backgrounds for each bird. In this original version before the white border was added, the whole scene gives the impression of being viewed through a round opening in the board.

MIXED MEDIA ON TINTED, TEXTURED PAPER

The study of two dogs on a more subdued shade of blue demonstrates the effects that can be achieved with a subtle blending of media. As in the painting of the wild birds, the predominating shade in the subject matter influenced the choice of background colour.

Even with a relatively simplified composition, it is advisable to do at least one rudimentary pencil drawing, which need be no more than a quick sketch to establish the main elements. It can also give the person for whom the picture is to be painted a good idea of what the artist has in mind. Having divided it into four sections, you can enlarge the drawing up to the desired size of the finished work.

I have used the heavier type of textured paper known as *Mi-Tientes*, which is available in thirty-five shades including black and white and is normally associated with pastel and chalk work, although it is also recommended for gouache, water colour and acrylic paints. When used with washes, it is best to bond it onto thin board to prevent 'cockling', or slight rippling, which occurs when a lot of water is applied. To ensure that the surface is smooth, an adhesive spray is ideal – but make sure the board is thoroughly coated before bonding! There are some instances where the support needs to remain flexible, for example, when the work is to be reproduced by a scan done directly from the original, which produces an even more faithful copy than a colour transparency made from it. In this case, fix the paper firmly to a drawing board on all sides with masking tape until completion, ensuring that broad washes are only used on a minimal area and are applied in small sections at a time, allowing each one to dry before working over it. This process may be hastened by the use of white blotting paper, if necessary.

Preliminary pencil drawing of Old English Sheepdog and Yorkshire Terrier, one half the size of finished painting.

METHOD

When you have filled in the outlines and main shadows, either with an HB or dark-coloured pencil, sketch light areas using a white pastel pencil, which goes on a tinted surface very easily, but comes off very easily too. So, as you progress, be sure that all traces of it are covered with ordinary white pencil, chinagraph or paint, as otherwise the pastel will eventually blur and disappear completely.

My portrait of this matronly, though spritely, Old English Sheepdog of fourteen summers, together with her diminutive companion, was done mainly from life. I also took a few colour snapshots in bright sunlight, which helped to give form and a change of colouring in the white fur, which would otherwise have tended to look too flat. None of the photographs showed the particular poses I had seen them in momentarily and

33

Detail, Yorkshire Terrier, in the actual size of the original.

Interestingly, when you paint in a neutral grey on a tinted surface, it assumes a tinge of the opposite colour from the background as for instance when you work on a greenish tone it appears to have been mixed with a bit of red. Take care that you use this tendency to the best advantage and do not exaggerate the opposite colour unless particular emphasis is required. Always have spare pieces of whatever paper or board you are using at hand on which to test the effect of each mixture of paint. I chose the type of ceramic feeding dish which is lined in blue to avoid a distracting contrast in this corner, and in the final painting, placed them closer together for a better composition. These were rendered with restraint using only coloured pencil.

I built shadows up in the background, and rubbed some places in and allowed the texture to come through in others to make the figures stand out and give them life. I used a dark, blue-green pencil, closely matching the tint of the paper when shaded from the light, and trimmed the shape of the dog's shadow on the left-hand side with a plastic eraser. The fur around the white feet is subtly defined with it as well.

Paper with such a pronounced texture makes it possible to work pencil on top of both thickly- and thinly-applied paint, similar to the technique known as scruffing, or scumbling, used in oil painting. The chinagraph pencils are particularly suitable for this purpose, especially when sharpened sufficiently so that the lead is exposed at the sides, but be very careful not to overdo it, for if the point is needle-sharp, it will break almost immediately. The reverse procedure of painting over the pencil work when the picture is nearly completed is a good device for softening the effect where needed. The white fur in shadow is an example where I added pale greys and neutralized yellow ochre and soft brown, restrained sufficiently to avoid having it appear orange on the blue paper. Last of all, final touches of really thick white paint were added onto the sunlit fur for the optimum illusion of three-dimensions.

which I found especially appealing, but in combination with close observation over a period of time, I was able to put down on paper just what I wanted.

Having sketched them next to each other, it was then easier to study each one individually. The larger dog was expressed in a careful mixture of media. The gouache applied both thickly and thinly, blends in most places with coloured pencil, and black and white chinagraph giving the fur a texture which resembles oil paint on canvas and is a distinct contrast to that of the little Yorkie, who was painted almost entirely in gouache with the grain of the paper obliterated.

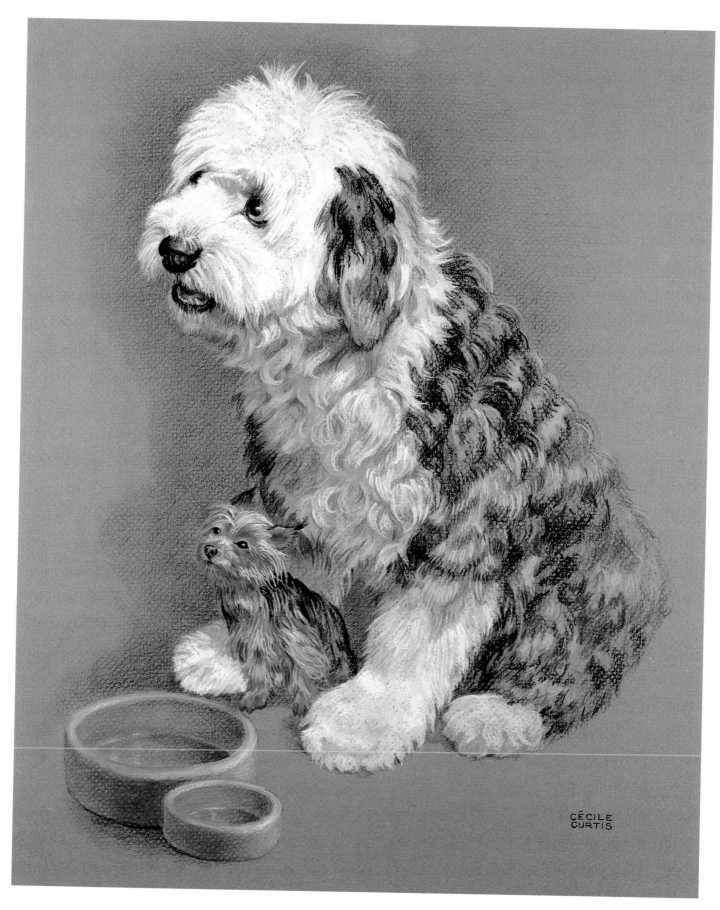

Tea-time, *gouache and coloured pencil on tinted, textured paper.* 425×333mm ($16\frac{3}{4} \times 13\frac{1}{8}$in).

WATERCOLOUR

This more traditional medium can produce effects similar to gouache and vice versa, but the principal difference is that watercolour is washed onto a white surface with pure colour, the degree of darkness depending on the amount of water with which it is mixed – the more water, the paler the shade – without any loss of brilliance. When you lighten gouache paints you must mix them with white, which tends to 'cool' the colour slightly, as though there had been either blue or grey added to it.

Watercolour is the most spontaneous of mediums, producing a sparkling effect when used by an artist who has mastered the special technique of sure and rapid application with the self-discipline to leave well enough alone! It is particularly suited to landscapes when capturing the fleeting changes that differing weather conditions make upon them, but is also a means of quickly conveying the form and colouring of animals in a bold and positive manner, or for adding just those small bits in a background to suggest the appropriate habitat without detracting too much from the figure.

Before painting the flamingo, I sketched in the outlines of the main elements with an HB pencil using a very light touch, any that remained afterwards being erased when it was perfectly dry. I first washed the body in with diluted Rose Madder and added the shadows on top of this with Vermilion and the accents under the plumage using Crimson Lake. Legs and bill are a pale wash of Yellow Ochre done with a No. 2 brush and accentuated by Raw Umber using an even finer No. 0, the tip of the lower mandible being emphasized with black. The cast shadow is a watered-down mixture of Indian Red and Vandyke Brown, while Sap Green, Cerulean and Ash blues plus Cadmium Yellow defined the suggestion of a beach habitat. To obtain finer detail, I chose smooth illustration board.

Supports are available in sheets, boards, pads and blocks, bound on four sides, in either smooth or textured surfaces. Paints come in tubes or solid pans, the latter being more convenient for smaller, field work and just occasional use. Watercolours, like most paints, are made in both artist's and student's quality, the more economic range offering less choice of

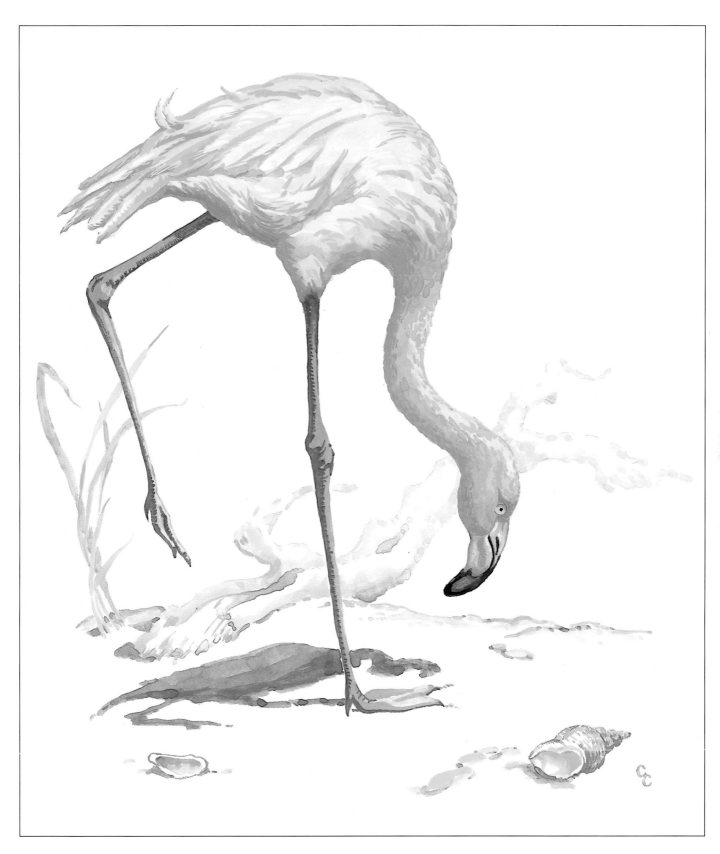

colours, although it includes thirty-nine. Many artists prefer working in a limited number of eight or twelve, which, on a previously wet surface, blend easily and very effectively into each other.

Greater Flamingo ('Rosy'). 204 × 178mm (8 × 7in).

OILS

Since mediaeval times, oil painting has been the most popular form of art, and the major works throughout ensuing ages, especially the larger ones, were created in this medium. Even today the unique shape of a wooden palette with its curves and openings for the hand and thumb, is a symbol of art.

Oil paint is basically a mixture of ground, pure colour pigments with linseed oil, which was, and occasionally still is, made by the artists themselves or, in earlier times, more often by their apprentices. At first, the containers were skin bladders followed by glass syringes. Finally, around one hundred and fifty years ago, the collapsible tin tube came into use and enabled artists to work in oils outside their studios.

Equipment for painters is constantly being improved and modernized. The classical wooden palette is now also made in oblong shapes to fit into boxes and you can buy melamine-faced palettes for easier cleaning or disposable ones in the form of tear-off sheets of parchment, though I suspect many artists still prefer a wood surface, well seasoned by many cleanings using turpentine followed by a well rubbed-in coating of linseed oil.

In addition to long-handled brushes made of hog's hair, sable, or synthetic substitutes, special small, flexible palette knives, other than those used for cleaning, provide an interesting variation in technique called 'impasto' painting where heavy layers of colour are applied producing very dramatic effects, especially for landscapes.

There is an even wider range of colours than in gouache paints. If the golden shades are included, there are as many as twenty-one different yellows alone! Some of their names differ from those on gouache colour charts – for instance, on the latter, 'Linden Green' corresponds to Cadmium Green Pale in oil paints. Therefore the list below includes the nineteen basic shades plus black and white. The selection could be whittled down even more as one of the advantages of painting in oils is that colours can be mixed easily – for example, Cadmium Lemon with a touch of black makes a lovely green for foliage which you can vary with small additions of white. The same applies to other bright colours with which it is well worth experimenting. All those named here are classified as 'durable' or extremely permanent. They are listed in the order I arrange them on my palette:

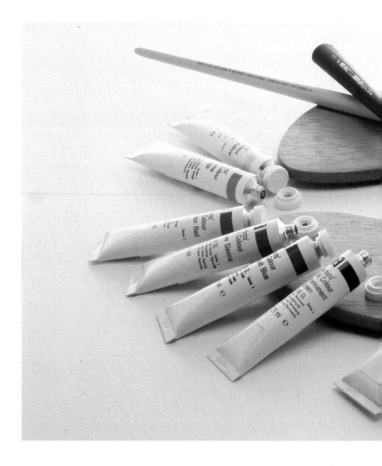

Zinc White	Scarlet Vermilion
Cadmium Lemon	Permanent Rose
Cadmium Yellow Deep	Cobalt Violet
The 'earth' colours:	Ultramarine Deep
Yellow Ochre	Cobalt Blue
Raw Umber	Cerulean Blue
Vandyke Brown	Viridian
Burnt Sienna	Winsor Emerald
Indian Red	Chrome Green Deep
Red Ochre	Cadmium Green Pale
	Ivory Black

Some find the slow-dying properties of oils a disadvantage, even when thinned with turpentine or its common substitute, white spirit. There are many types of thinners, solvents or 'mediums' with which to mix colours to a given consistency, depending on whether a matt or glossy finish is preferred and whether you want it to dry quickly or remain capable of being worked into. There are also slow and quick-drying linseed and poppy oils as well as white spirit or turpentine, plus the slow-drying and more pleasantly odoriferous oil of spike lavender. These are placed in metal dippers clipped to the edge of the palette, either singly, or in pairs.

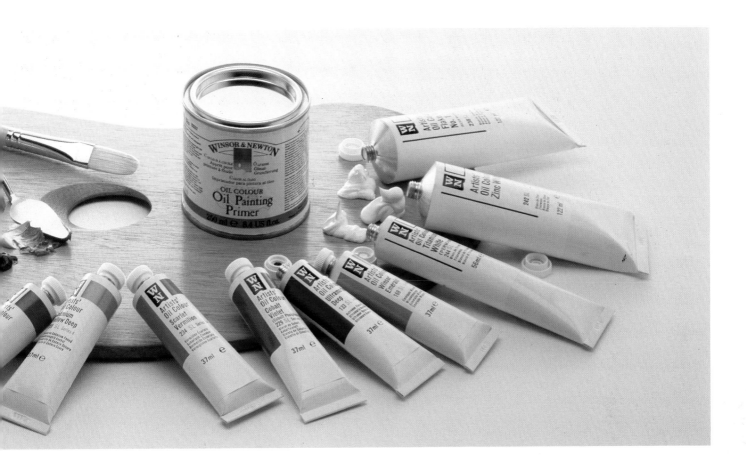

BRUSHES

High quality brushes of varied sizes and shapes suited
to specific needs, are an important investment as well
as an aid in achieving good technique. If you look
after them by cleaning them in a solvent and then
washing them out with soap and warm water at the
end of a day's work, they can last for many years. For
oil painting, long-handled brushes are normally
preferred, either flat or rounded, with hog's bristles or
red sable hairs, which can be short or long, tapered or
squared. Cheaper versions are made with polyester or
nylon fibres. Red sable brushes come with very fine
points and are known as 'riggers', originating from
the days when they were used for the fine lines of ship
rigging. Then there are fan shapes particularly suited
to delicate interpretations of hair and fur.

An indispensable item is a mahl stick, which is
useful for resting your hand when executing fine
detail. Mahl sticks are manufactured commercially,
but you can easily make your own from a wooden
dowel attached at one end to a rounded piece of wood
or cork, covered with chamois leather and securely
bound at the base. Place this at the edge of the
canvas, holding the stick in one hand and resting the
other on its length without disturbing the wet paint of
the surrounding area.

CHOOSING THE SURFACE

Oil painting can be done on wood, or on either the rough or smooth side of hardboard, provided all surfaces are first 'sized' on both sides so that they are not absorbent and do not warp. Undoubtedly, the ideal support or 'ground' is canvas on either wedged stretchers or in the form of panels or boards, which are more manageable, particularly for those who prefer a firm, unyielding surface. All of these are available in varying selections of rough or smooth textures, but that of the boards tends to be rather too regular a weave. A recent innovation is oil painting or 'sketching' paper, which comes in blocks measuring up to 508 × 406mm (20 × 16in) or heavy sheets of 762 × 508mm (30 × 20in), in smooth or rough and is quite inexpensive as well as an amazingly good facsimile of the best quality, stretched canvas. When buying a sheet, it is wise to have it carefully rolled, preferably around a mailing tube, to avoid any possibility of dents. You only need to flatten it out on a drawing board or piece of hardboard, a bit larger than the required size of your picture, securing it on all sides with masking tape until completed. When thoroughly dry, it can be conveniently stored or placed in a portfolio.

PAINTING A PORTRAIT

The most convenient subject is my own 'resident model', a black Great Dane with a velvety coat, whose face has acquired even more character by the whitening of his brows and muzzle with a faint dusting of white hairs on the cheeks.

I used coarse grained canvas paper for this study, choosing a flexible type so that it could be wrapped around a colour scanner when reproduced. His head is very large and I have made it life-sized, choosing a front view to show his expression to better advantage. It is the look he has when he realizes that I am going out without him, one which haunts me most of the time until I return!

THE PROCEDURE

After making a quick sketch to determine the best angle and placement, I drew in the outlines on the canvas with a pencil, blocking in the main dark areas with black mixed with a little Ultramarine and white. I next put in some of the adjacent background, a mixture of Cadmium Green Pale, white and just a touch of black to tone it down, varying it slightly here and there with the addition of Chrome Green Deep. As I did not want the portrait to end abruptly at the neck, it is done as a vignette with the light background fading out to nothing on the right, its bright colour enhancing the black fur. The next step was to establish the middle grey tones, in which some areas were mixed with a subtle suggestion of Cobalt Blue, more pronounced at the top of the head and nose. These were applied quite thinly with just enough turpentine to make the paint flow easily without running. Although the coat is very sleek, its dark outlines are intentionally allowed to 'bleed' into the yellow-green for a softer texture, as a hard black edge would not have had a fur-like quality.

I applied grey over the black and vice versa, letting the grain of the canvas come through and then finally pure black more positively where appropriate, building up the form all the time. The lightest greys on brows and nose were painted on top and the muzzle is varied mixtures with a slight suggestion of Red Ochre. The irises of the eyes are Cadmium Yellow Deep – really an orange – going into shadow with Burnt Sienna and Vandyke Brown. The highlights have Cobalt Violet in them for a softening effect, whilst those on the nose were made with Cobalt Blue. The fine, white hairs were indicated lightly with a rigger after the under painting had dried.

Oil paint is undoubtedly an excellent medium, but best suited to the larger scale of work for animal subjects.

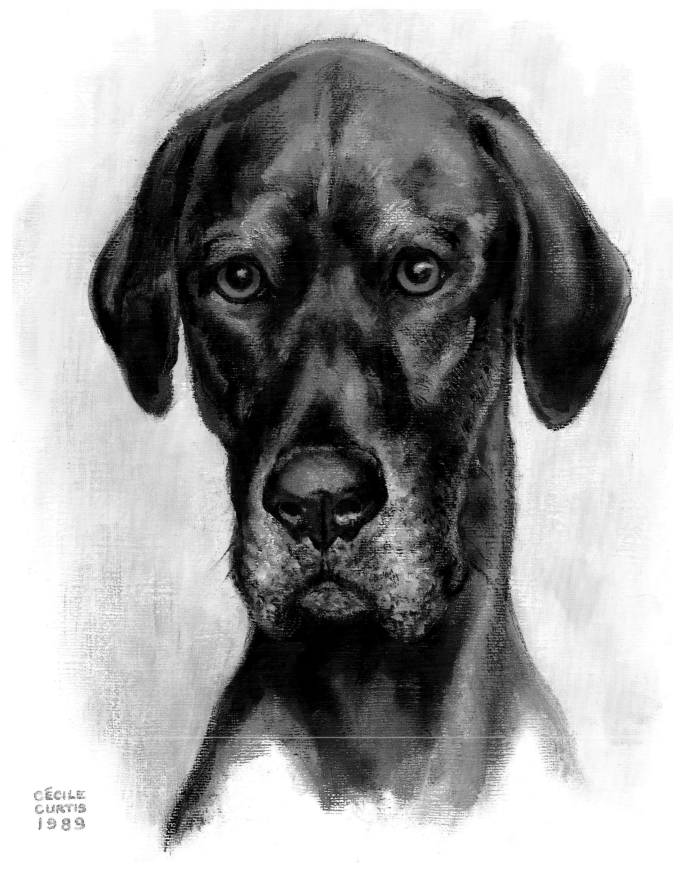

CÉCILE
CURTIS
1989

Zeus of Bonnoakleigh ('Oscar'). Oils on coarse grain canvas
paper. 432 × 356mm (17 × 14in).

OTHER EQUIPMENT

THE PORTABLE STUDIO

In addition to the materials previously mentioned, you will also need an easel for oils or large watercolour and gouache paintings. There are several versions in wood or aluminium, but an easel sketch box, combining several functions, is undoubtedly the best. As a container for paints, palette and brushes, plus other accessories, it can be used outdoors or in and is truly a 'portable studio'. The three folding legs are easily adapted for standing or sitting; when you work outside, they can be individually adjusted for uneven ground. They are also reversible with a spike at one end for gripping into soft earth.

I can certainly vouch for the durability of an easel box – mine once withstood a stampede of cattle, though *I* did not. I was painting a landscape in the Berkshire mountains of Massachusetts, having picked an ideal spot at the foot of a very steep hill, when this peaceful ambiance was abruptly shattered by the sound of pounding hooves. Looking behind me, I saw to my horror that a herd of cows had just mounted the crest of the hill and, consumed with curiosity, were hurtling down towards me! I left everything and ran. After they had satisfied themselves that this strange apparition was harmless, they wandered off at last and I came back, finding to my intense relief, all was intact. The same equipment withstood another siege by a lake in Pennsylvania where I had unknowingly chosen a spot right near a swan's nesting site. Inevitably, an angry cob appeared from nowhere, menacing me with powerful wings. I dismissed my initial impulse to save the canvas at least, and empty-handed fled ignominiously, returning only after a discreet interval to shift my vantage point to a safer place.

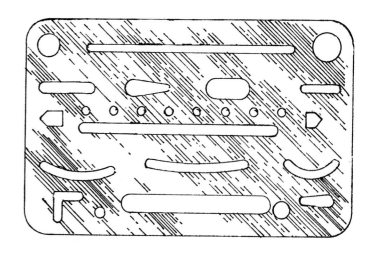

Erasing shield – actual size, 57 × 84mm (2¼ × 3½in)

AIDS TO WORKING IN PENCIL

Two surprisingly useful small articles are an erasing shield and a tortillon, or torchon, which is a slim rolled paper stump, pointed at one end. The first item is made of strong but flexible and paper-thin metal with different little shapes cut out, allowing minute erasures in limited areas on all types of pencil drawings without disturbing the rest. The second, usually associated with pastel work, is perfect for smoothing a narrow line of coloured pencil. A good example of this where a deeper tone of the background colour was needed to outline the fine tufts of white fur in the gouache/pencil rendering of the two dogs on page 33.

Easel sketch box can be carried like a suitcase as telescopic legs clip to sides. Equipped with palette, deep drawer, metal inner tray, it takes canvasses or boards up to 850mm (33½in).

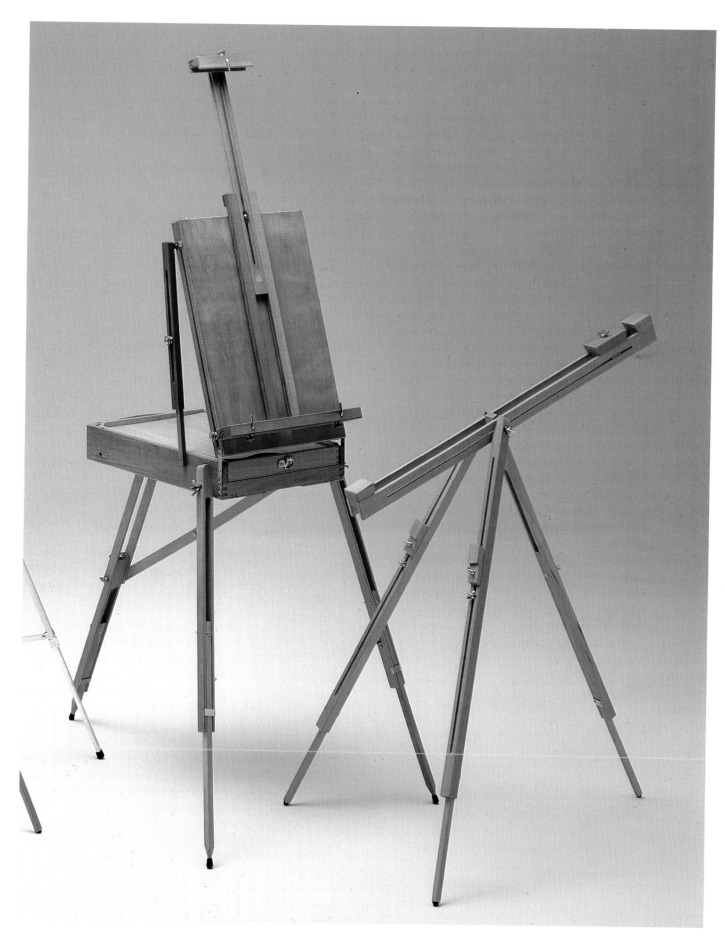

43

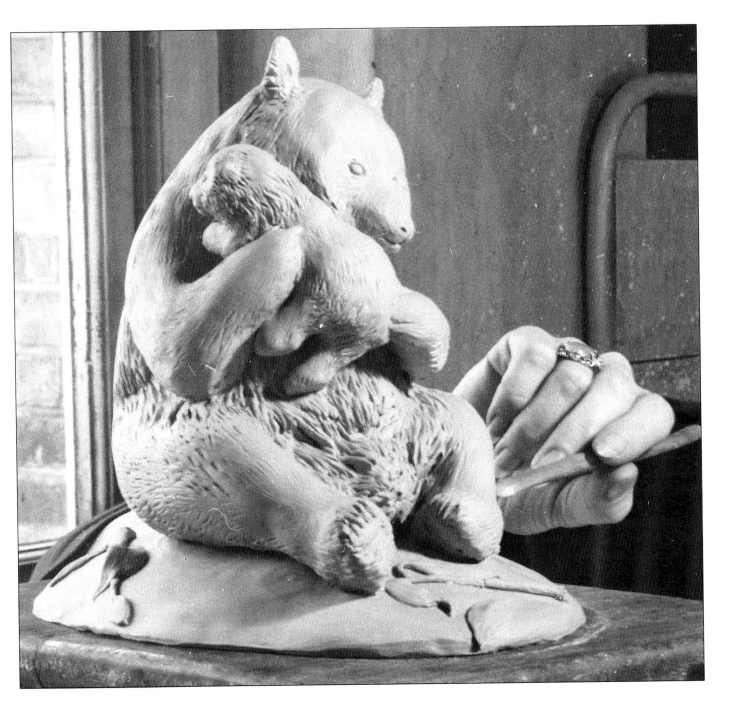

SIX

SCULPTURE

The creation of three-dimensional figures naturally involves a thorough perception of the subject matter from every angle, plus a fair amount of ingenuity. There are fewer rules and guidelines than in two-dimensional art, and there is the constant challenge to achieve the near impossible in this medium, conveying texture and movement, especially in the case of animals. You must also bear in mind the

Clay model of Giant Panda and cub on very simplified plinth strewn with bits of bamboo.

balance and means of support for your subject. Despite these drawbacks, sculpture can be immensely satisfying. It offers a certain freedom which other media do not, as one actually has the added bonus of being able to work with both hands.

CLAY MODELLING

The figure of the Giant Panda and cub was the beginning of a series of rare species produced as

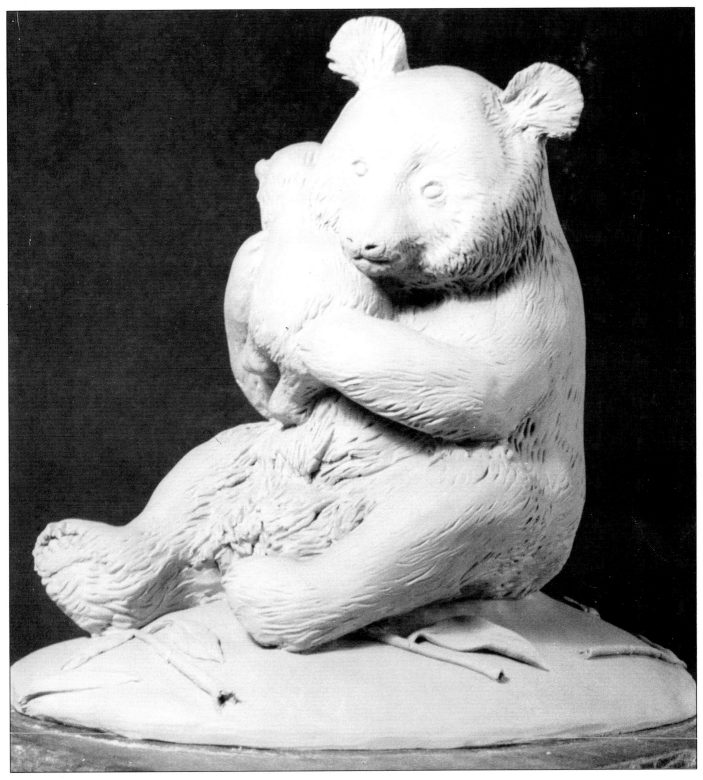

Close-up shows fur's texture but lacks its characteristic black and white pattern.

limited editions in porcelain. In this instance, I did not have the limitations of a monochrome finish, as they were all to be painted after the initial firing. In this respect, I was fortunate in having access to a resident panda at Regent's Park, London, and could make notations of the surprising variation in the colouring of her fur.

The first four figures in the project were done with modelling clay which had to be kept damp with a fine spray of water at the end of a day's work and immediately covered with a large plastic bag, as

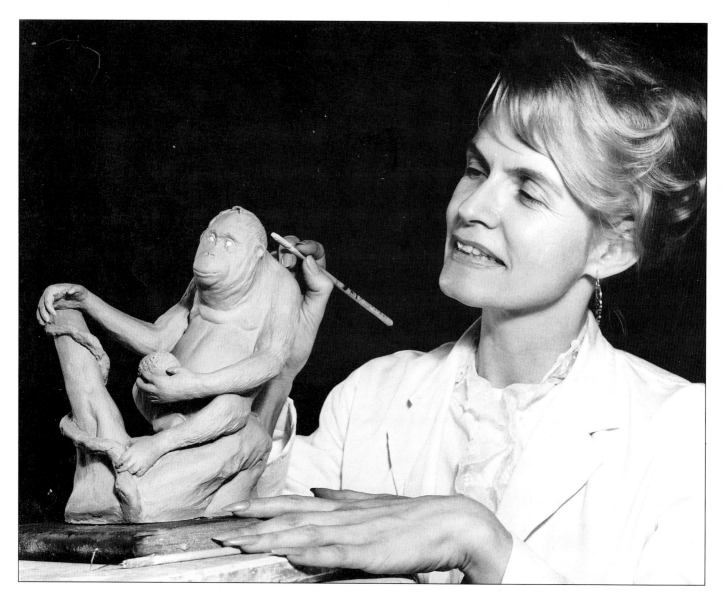

Here I used specially-adapted chopsticks to add final details to an orang-utan in Spode's studio.

airtight as possible. The mechanics of producing the initial animal were certainly comparatively simple without the complications of projecting parts and delicate vegetation, although the entire series was done to a scale of one-seventh life size, which meant checking constantly with a tape measure in the early stages. When completed, I transported it from London up to the Spode Works at Stoke-on-Trent, keeping it moist with a spray bottle throughout the train journey, and attracting many puzzled stares from fellow passengers!

Next in the series was the orang-utan, for which I used wire through the forearm and the portion of the tree branch on which it is resting. I made a rough outline drawing of this part for the chief mould maker, indicating in red the exact location of the armatures. This master craftsman would subsequently study and photograph each group, or composition, from several angles before carefully removing any wires and cutting it into separate sections from which individual moulds were to be made. These parts were then ultimately reassembled, and on my next trip to the studio I smoothed out the seams which remained before the figure was fired. After many weeks of work, it was always a somewhat distressing experience to see the results of my labours cut into small bits, one to which I never became fully accustomed, but the resulting fine reproductions made it all worthwhile.

Not many art shops carry accessories for sculptors; you must either find specialist manufacturers or improvise. My husband fashioned a most efficient array of modelling tools using a set of chopsticks to

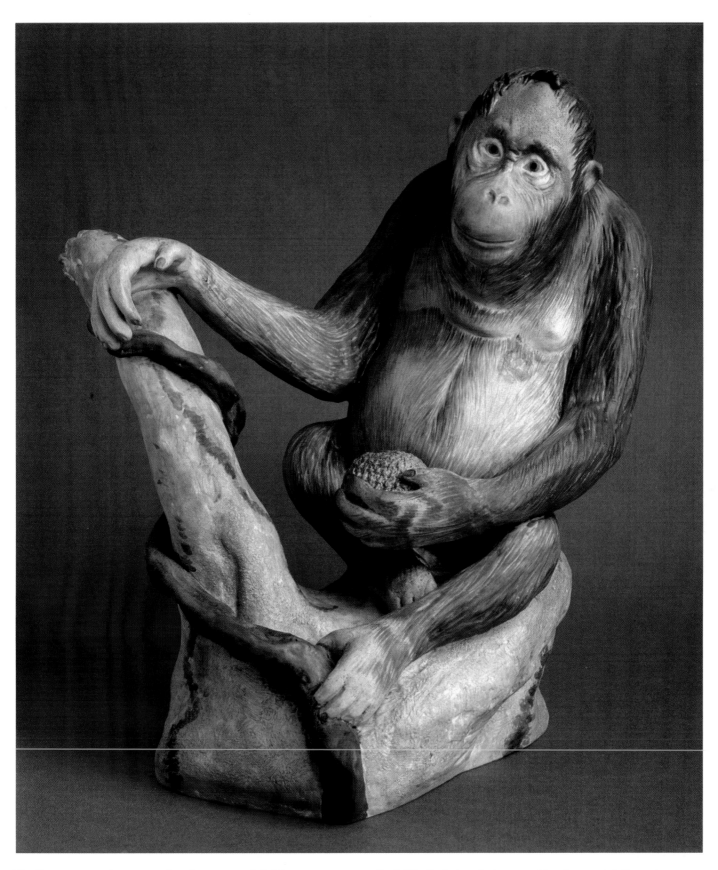

The figure in porcelain, now shrunk to one-eighth life-size, which I painted with watercolours as a master guide for studio artists who must use special paints that change colour when fired. The fruit is a durian, considered a great delicacy by orangs despite its rather overwhelming odour to most humans! I made the durian separately and placed it in the hand afterwards.

47

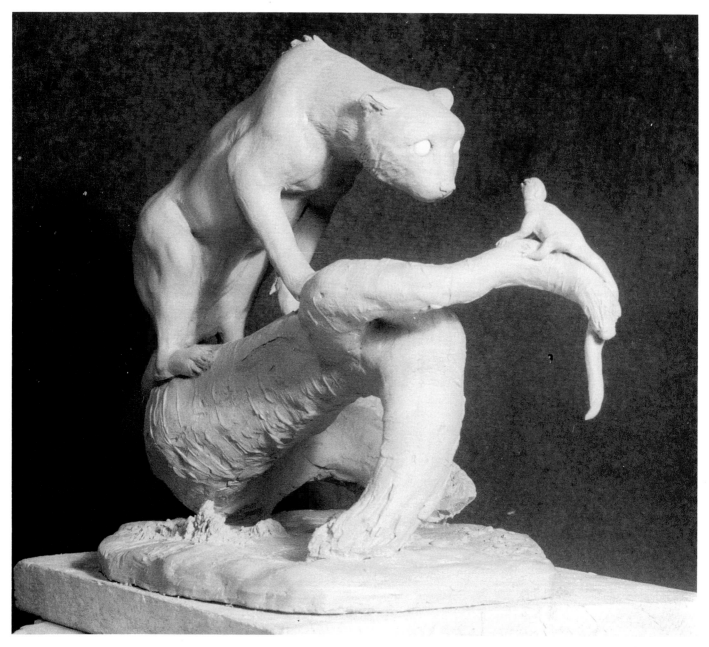

Model of a cheetah, identifiable by its unique frame, despite lack of distinctive markings at this stage.

some of which he attached wires, twisted into different shapes, and formed the tips of others into suitable tools for smoothing purposes. We had heavy boards cut to use as bases, glueing a layer of foam rubber to the bottom surface, which prevented it slipping but still allowed the board to revolve easily when required. One of these was circular with a hole in the middle into which a wooden dowel could be placed as a support for an animal standing on all four feet, though this is not usually necessary when working on a very small scale. It could then be drawn out at a later stage after building up the legs, and the

hole underneath the stomach smoothed over before working on the plinth on which the feet will rest.

Resourcefulness also comes to the fore in finding appropriate items to form the core of a figure around which the modelling material can be built up, because without this, the body may be too heavy. Light-weight wood, polystyrene, finely-meshed tubes, etc., can serve the purpose.

The cheetah with its lithe, slim body, did not require a supporting dowel or core, only needing wire armatures in the front legs. I also used them in the vertical tree branch and a very thin one for the lower part of the lizard's tail, to protect it during transportation. This was later tapered down to a fine point just before moulds were made from it.

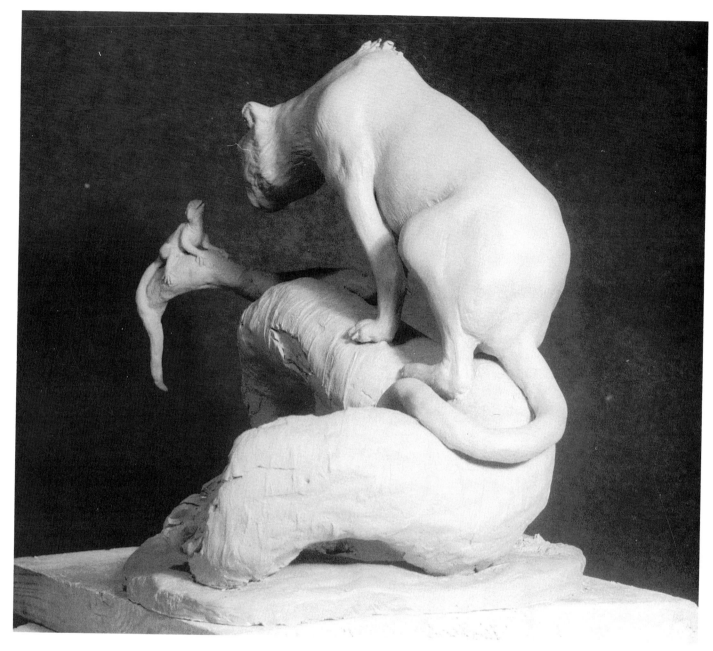

Back view with face of Agama Lizard just visible. I used the tiniest beads for its eyes.

I chose an Agama Lizard as the focus for the cheetah's or 'hunting leopard's' attention, since not only is it very colourful, but its face has the amusing characteristic of turning a crimson red when agitated!

For the texture of the tree bark I painted around the branch with several applications of 'slip' – clay that has been gradually thinned with water and mixed to the consistency of heavy cream.

Beads are excellent for suggesting the sphere of the eye in sculpture. Having roughly formed the shape of a head, I make sockets for eyes and press beads into them, covering them with eyelids and sometimes even a suggestion of eyelashes as well!

The cheetah's claws, though very minute, were made individually and then slipped into holes in front of the paws, giving a more realistic effect.

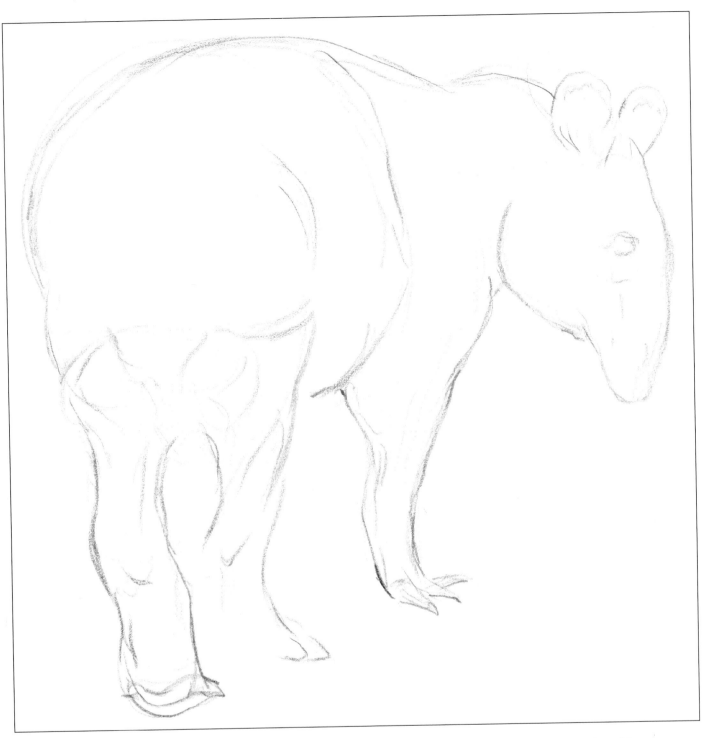

When planning an animal sculpture, some spontaneous, rough sketches help to decide the overall composition or pose of figures. London Zoo's Malayan Tapir, 'Robbie', was a more than usually co-operative model. I selected a large sketch book, holding the pencil like a knife-handle and using the wrist and arm as well as fingers to draw this odd-toed, aquatic mammal with its highly adaptable and sensitive snout. The curiously long proboscis is used like an elephant's trunk when feeding, and is constantly

Outline of Malayan Tapir drawn in pencil from life.
221 × 226mm (8⅝ × 8⅞in). This rapid sketch, as the animal walked away, was the ideal position for the figure of the mother, turning to look at her offspring.

changing, extended when probing for food or sniffing its surroundings.

Related not only to the rhinoceros, but also its less likely cousins, the horse and zebra, it makes an unusual and interesting subject for sculpture. The

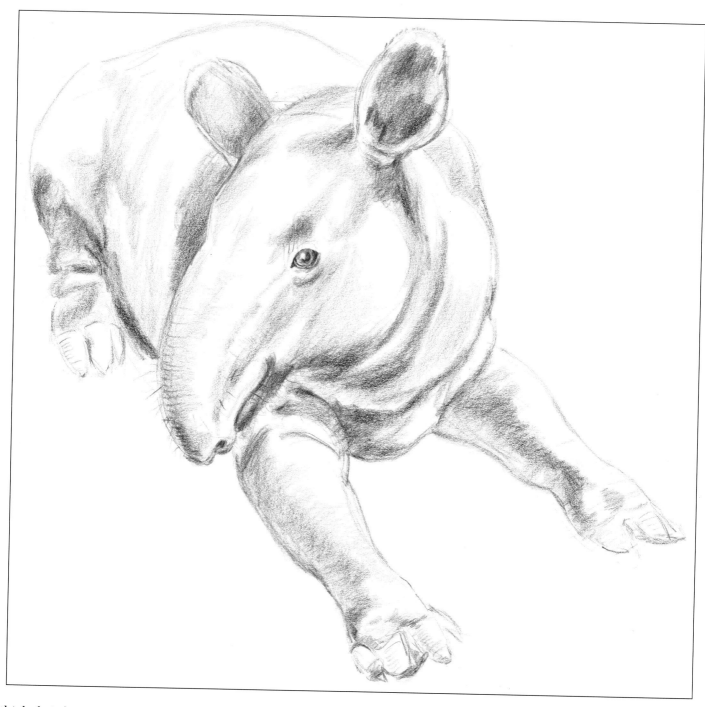

thick, bristly coat is dark to reddish-brown in the South American races, but those with a large area of white blanketing the body are only found in far-off Malayasia. I chose the latter for its contrast, bearing in mind the painting of the figure at the porcelain stage.

It is important in portraying any animal by whatever means, to acquire some knowledge of its habits as well as details of its physical characteristics. In the wild, the tapir is elusive and nocturnal in its activities as well as being sparsely distributed and dwindling in numbers in the habitats of all four

Reclining tapir in sepia pencil. $285 \times 290mm$ ($11\frac{1}{4} \times 11\frac{5}{8}in$) He held this pose long enough for me to make a reasonably detailed study.

species. I was indeed fortunate in finding so readily accessible a specimen as the amiable 'Robbie' who seemed quite content to bask in the gentle and infrequent rays of British sunlight – especially as fruit and greens were in constant supply.

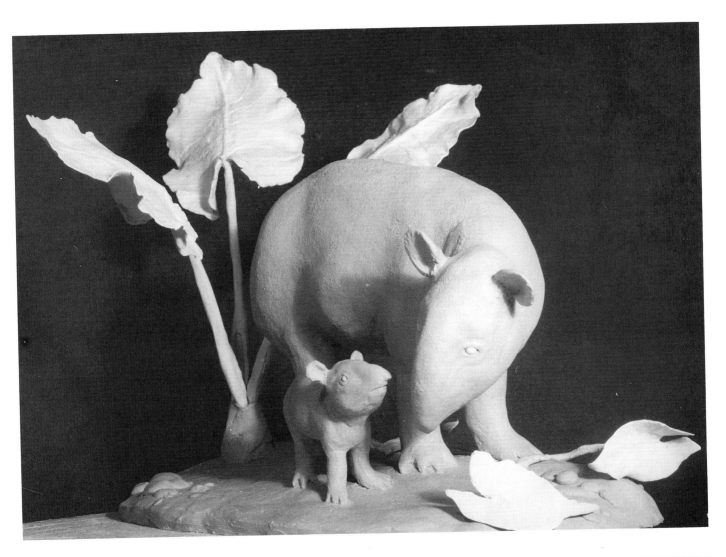

Above: *Early stage of tapir and baby.*
Right: *Painted* aracaea *leaf from above and underneath.*

CLAY PLUS WAX

For the delicate flora in this group, I choose modelling wax, which is easier to use and more durable than clay. The wax is a petroleum by-product that comes in solid, rock-hard blocks. You must melt these down in an old saucepan on a low heat, adding petroleum jelly in varying proportions, depending on the degree of flexibility needed. Pour the mixture into a shallow container to form thin, workable sheets on cooling. For this purpose, I use round melamine trays lined with baking foil, which is easily peeled off when ready.

To suggest a moist, evergreen jungle habitat, I added an *aracaea* plant which involved many detailed colour sketches, plus taking the actual measurements, at Kew Gardens. It was conveniently in bloom when I visited this vast, tropical greenhouse, and in the more complicated version, I included its lone, orchid-like,

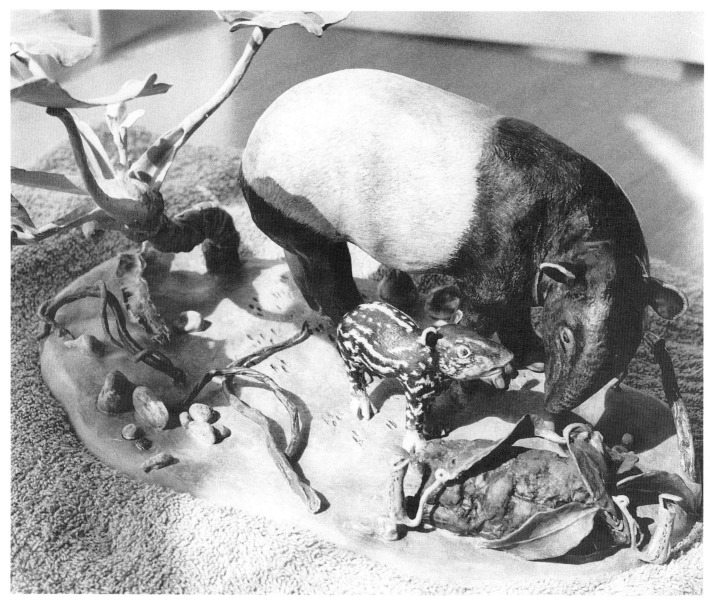

Painting completed of figures and more complicated habitat.

yellow flower, which grows at the base of the huge, overhanging leaves. Research had to be done on various exotic pitcher plants for the type appropriate to the area. This plant also has a neat lidded container, holding the pungent liquid that attracts the insect prey. I added variegated pastel-coloured pebbles, part of a tree trunk and twisting Iliana vines. On the plinth can be seen the prints of the creatures' odd assortment of tiny hooves – three on each of the back feet and four on the front ones. The young tapir has the same markings as the offspring of all the other races and, only with maturity, acquires the distinctive white area peculiar to the species on the Malay Peninsula.

When the porcelain figures were returned to me for painting, all the fragile parts were separate, most of them being so fine, the light shone through them. They had to be assembled and glued together firmly before the watercolours were applied.

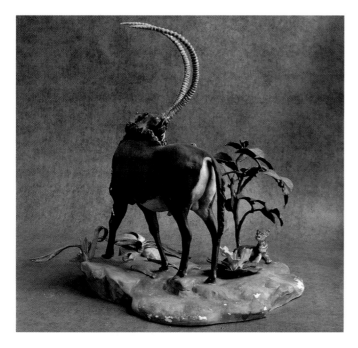

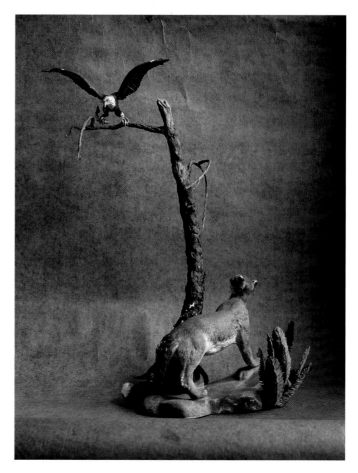

Above: *Giant Sable Antelope with serval hiding under bush. An oxpecker is just visible on the antelope's back.*
Right: *American Bald Eagle with puma. Both of these endangered species are found in Alaska.*

The Giant Sable Antelope was the first sculpture for which I used a combination of wax and clay on the figure itself. The body had a light-weight core to minimize the strain on the delicate legs, which were constructed around wire armatures as was the long tail, but they would not have been sufficient to support the incredible length of spiralling, curved horns. I solved this problem by modelling the horns in wax and then fitting the root ends into holes made above the temples. These were transported and cast separately and later fitted together for firing in the kiln using an elaborate system of supports.

The bush, other vegetation and the reclining serval underneath were also made in wax. I researched each of these items, checking on their suitability for the local environment in the west African province of Angola, home of this handsome and extremely rare species of antelope. I chose a very small member of the cat family to contrast with the antelope's imposing height.

MODELLING IN WAX

As the series progressed, I was asked to present even greater challenges to the mould makers in the intricacies of my creations. This meant that entire groups, including habitat, now had to be constructed in wax, of which the most daunting was the combination of two rare species together. The puma, also known as the mountain lion, or cougar in the United States of America, inhabits a widely dispersed territory from western Canada down through South America, although its declining numbers throughout make it an endangered species. I chose an Alaskan habitat containing another very rare creature, the Bald Eagle, so called because of its white head. The environment shown here is limited to the broken trunk of a sitka spruce, typical of the area, with bracket fungii and browning ferns on the ground. The eagle clutches a freshly acquired meal of fish, attracting the attention of the feline below and presenting an amusing situation. The tree and its branches were the only parts requiring wire armatures.

The largest and most ambitious of the various groups is undoubtedly that which features the Ceylon elephant, originally accompanied by an indigenous leathery turtle slithering onto the beach. It was decided that the combination of palm tree and elephant were sufficiently spectacular, and the plinth was eventually confined to the painted portion covered with shells, a starfish and fallen branch.

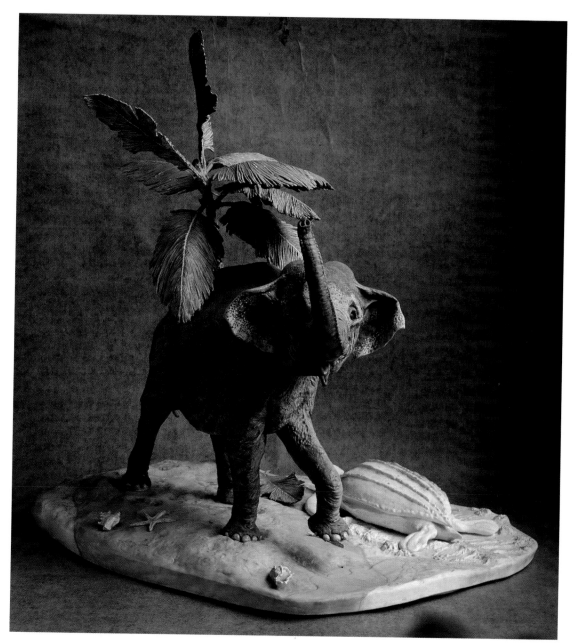

Above: Ceylon Elephant with leathery turtle, later omitted.
Below: Side view, showing minimal contact with palm tree.

Viewed from the front, the tree fronds and trunk seem to be supported by the elephant's back, but the only point where one of the branches touches, is shown in the side-view drawing.

As this breed of elephant is very rare, it was difficult to find good photographic references, especially in colour, to determine just where it differs from the more common Indian species; its most distinguishing characteristic, I found, was the pronounced freckling on the pink pigmentation of the face and ears. With the variation in the texture of its skin, it makes an ideal subject for modelling in wax.

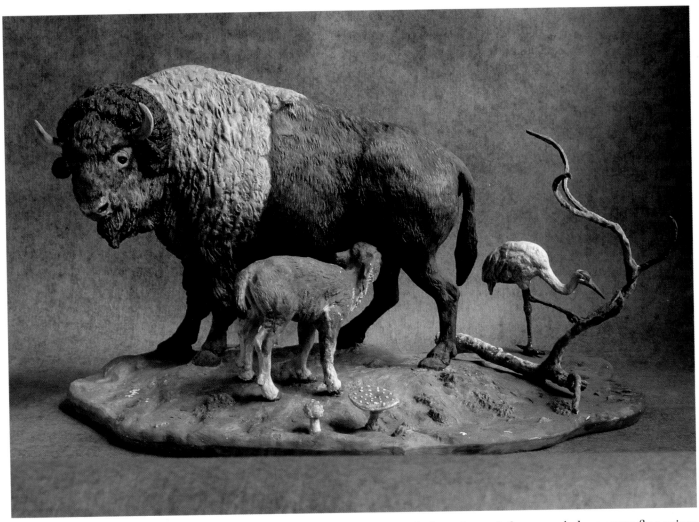

Canadian Wood Bison with summer visitor, the North American Whooping Crane.

Another animal especially suitable for this medium is the Wood Bison, the northernmost cousin of the smaller and more familiar American Buffalo and also the rarest. The woolly golden mantle around its shoulders, which moults during the brief northern summer, presents a striking contrast, not only in texture, but colouring, while the rufous-coloured calf offers yet another variation.

By a fortunate coincidence, its last remaining habitat, the Wood Bison National Park in Canada's North-West Territories, is also the summer home and breeding ground of an even more endangered species, the Whooping Crane, tallest of American birds, which stands 1.53m (5ft) high with a wingspan of 2.34m (7$\frac{1}{2}$ft), its bright scarlet head plumage adding a splash of colour to the composition, which only needed the simple environmental addition of a few toadstools, clumps of greenery and the branch of a silver birch. Here again, the heavier animal required a sizeable

core to lighten it, and the crane's legs were fine wires, thinly covered with wax.

Besides wax and clay, there are other materials worth investigating. The relatively new *Cold Clay* hardens into a silvery-grey colour if left in the dark, or black if in daylight, though it is not practical for use with armatures as it shrinks slightly, whereas another, called *Plas Dur*, does not. The most readily available medium is ordinary children's *Plasticine* which can usually be found in several colours, the most suitable for animals being the more neutral tones of stone, terracotta, grey, black or white. Unlike clay, it need not be kept wet and, as with wax, it can be softened with petroleum jelly. It is most convenient for modelling smaller figures or for using outside the studio.

DOMESTIC
ANIMALS

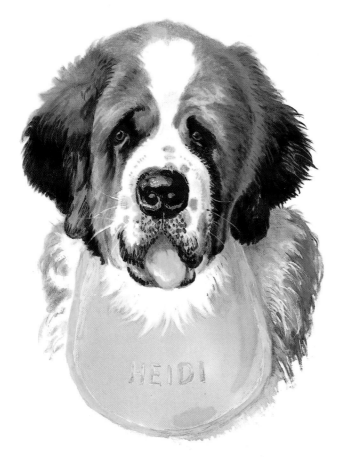

Mangabey Monkey, despite the fact that chimps occasionally include the latter in their mainly vegetarian diet. Family groups of chimps have also been seen travelling with a young long-tailed monkey, which had obviously been adopted as a pet, the females in the troupe taking turns carrying and fondling it. In another remarkable case, an adult male zoo inmate became so attached to a baby rat which had found its way into his cage, that he fiercely resisted any efforts on the part of his keepers to remove it. He would spend hours gently stroking the small rodent as it lay quietly in the palm of his hand.

The universal appeal of pets lies partly in their dependence on their owners, partly in their unswerving devotion and a childlike innocence, even when they are mischievous. An excellent example is the dog, who is really a domesticated wolf, having become man's companion some 12,000 years ago, and is aptly described by the zoologist, Desmond Morris, as a permanently juvenile version of its wild counterpart. It is this 'Peter Pan' quality which arouses in us a parental response, regardless of the size or age of the animal, inspiring a desire to protect, care for, and caress them and also of course, to have their portraits painted.

St Bernard. *Broad-nibbed and brush pens in combination with coloured pencil and gouache. $104 \times 78mm$ ($4\frac{1}{8} \times 3\frac{1}{16}in$) Oversized baby's bibs are always worn by this breed before entering the show ring in order to keep their chests dry!.*

SEVEN

PETS

Pets are undoubtedly the best and most readily accessible source of subjects for the aspiring animal portraitist, especially your own.

Keeping pets goes back to prehistoric times and satisfies a basic need in the human psyche. Ethologists – those who study animal behaviour – have even established the existence of protective and friendly behaviour between different animal species, notably chimpanzees. One chimpanzee was observed in the wild delicately attempting to free a baby chick that had been tied up, and another helping a juvenile

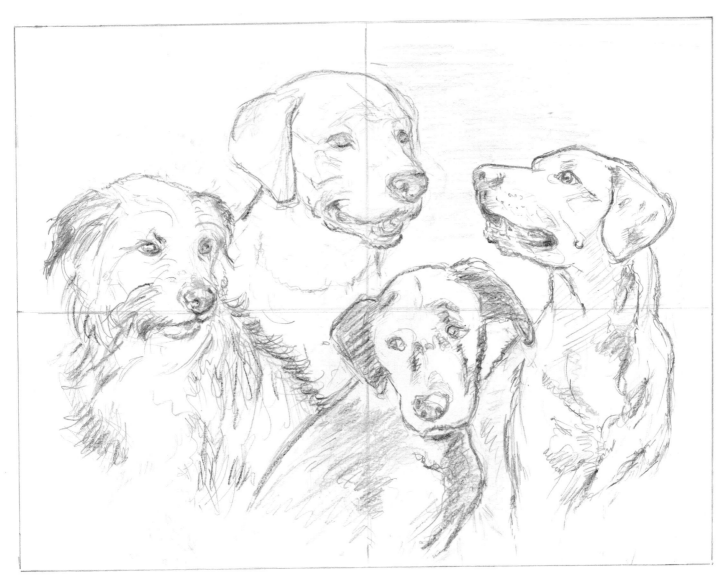

Preliminary sketch, one half size of finished painting.

CANINE STUDIES

As animals never assume the ideal pose at the right moment; it is essential merely to observe them initially, looking out for a similar, or even better, pose to the one you planned. In dealing with portraits of dogs, it is helpful to enlist the co-operation of the owner or a friend to persuade the subject to assume and remain, however briefly, in the position you are after. Some rapid sketches can if necessary be combined with a selection of snapshots, preferably those taken specifically for the purpose, to help with detail and fur textures, although be wary of photographic distortion in foreshortening and exaggerated colouring. These will suffice for the preliminary drawing to establish the main elements in the picture. This can then be enlarged up with some indication of the main colouring and shading. At this

stage you are ready for a further 'sitting', examining your model at close proximity to look for details which not only express the characteristics of a particular breed, but more specifically, that individual animal.

In this portrait of four dogs, the composition was the first consideration. It needed to be an attractive grouping with the heads shown in slightly different attitudes, and placed so as to complement each other's colouring. I checked their relative heights and the length of each head, even though I planned to avoid showing them all sitting in a line, and also allowed for perspective. The two Labradors on the right are the six-month-old offspring of the white one at the back, the smaller of the two being the black female. By placing her in the foreground, I made the size of her head nearly the same as the other three, thus giving all four portraits equal prominence.

As is my usual practice, I first observed their individual personalities, asking the owner about their

different traits and behavioural patterns. I learned that the crossbreed is a rugged individualist who had been rescued from his previous cruel owner. The mother of the two pups is a cherished family pet, gentle and very loving, and her Titian-haired son, a lively and spirited youngster, contrasted with his smaller, black sister, who is very much a loner, affectionate but somewhat shy and retiring.

Next, I worked out the composition in the rough pencil sketch. It is exactly half the size of the finished painting in order to make it easier to enlarge. Having divided them both into four equal sections, I drew the subjects in very lightly onto a textured paper with a raw umber tint I had selected from a choice of pale brown and golden tones as it was a paler version of the wall where the picture would be hung. I used black plus a limited range of coloured pencils initially. These were then worked up to a more finished state when, with the owner's help, I was able to make a close study of each one while she held, cajoled and bribed them in turn. I established the subtle changes in their colouring and other details, still with coloured pencils, using the stronger chinagraph only for sharp accents of black, brown or white. Afterwards, gouache was gradually painted over most of these areas and the colours heightened to make each figure stand out from the background. Note that the teeth are far from white as generally they do not catch the direct sunlight, and in any case, to have made them so would have looked grotesque. Instead, I used a touch of raw umber, yellow ochre and black mixed with the white. The same principle also applies to the whites of the eyes, which were toned down with black and red ochre, greying a bit more at the corners to make them rounded. The highlights of black fur and noses are conveyed with a little turquoise blue mixed into the greys and also in the highlights on the pupils of the eyes to soften their expressions.

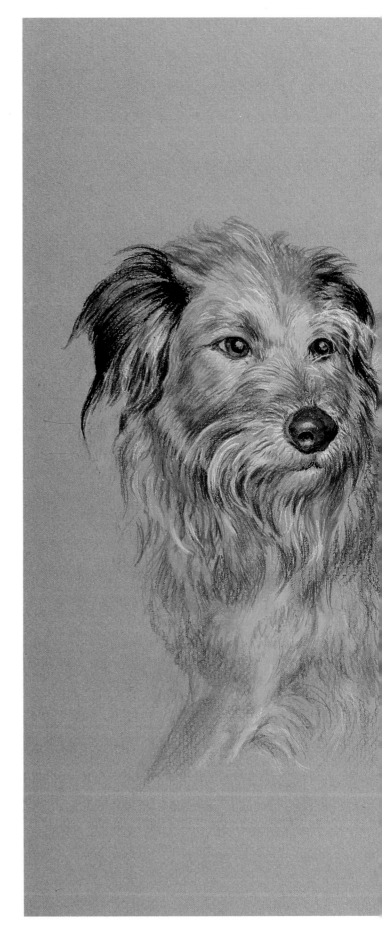

Barney, Penny, Petra and Lucas. *Gouache and coloured pencil on textured, tinted paper mounted on board. 407 × 508mm (16 × 20in).*

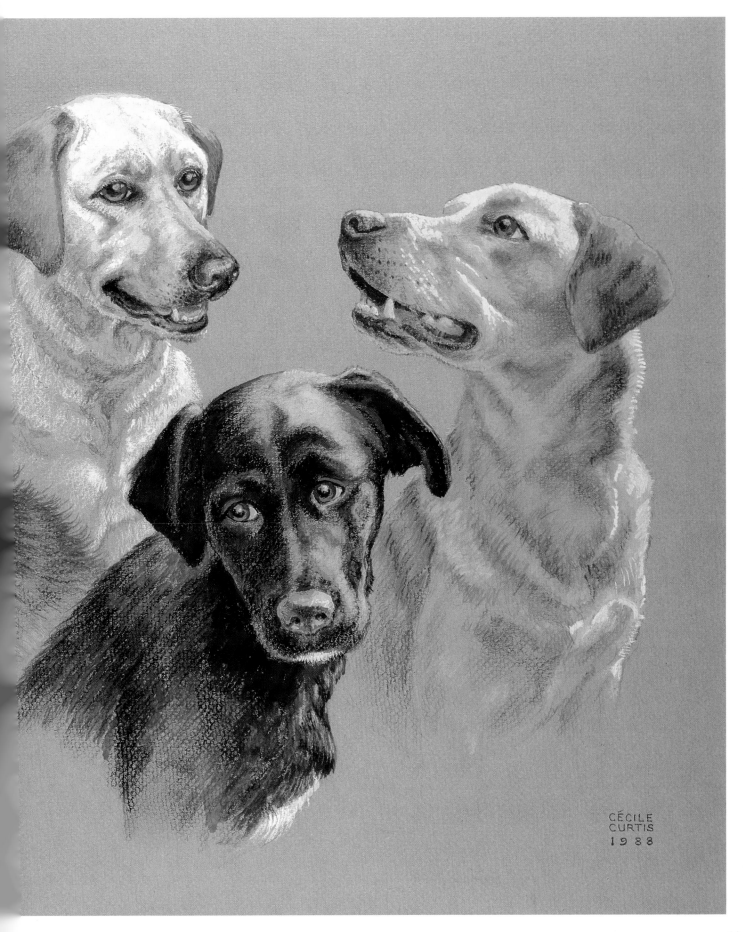

CÉCILE
CURTIS
1988

61

Pelajilo Sappho at Bridoreen ('Sappho'), Old English Sheepdog at the age of four, with first litter of ten puppies I drew from life when they were five days old, using coloured pencils on textured, light-blue Ingres paper. The sketch took three-quarters of an hour, and the fur was added afterwards with black and white chinagraph pencils. 173 × 450mm (10¾ × 17¾in).

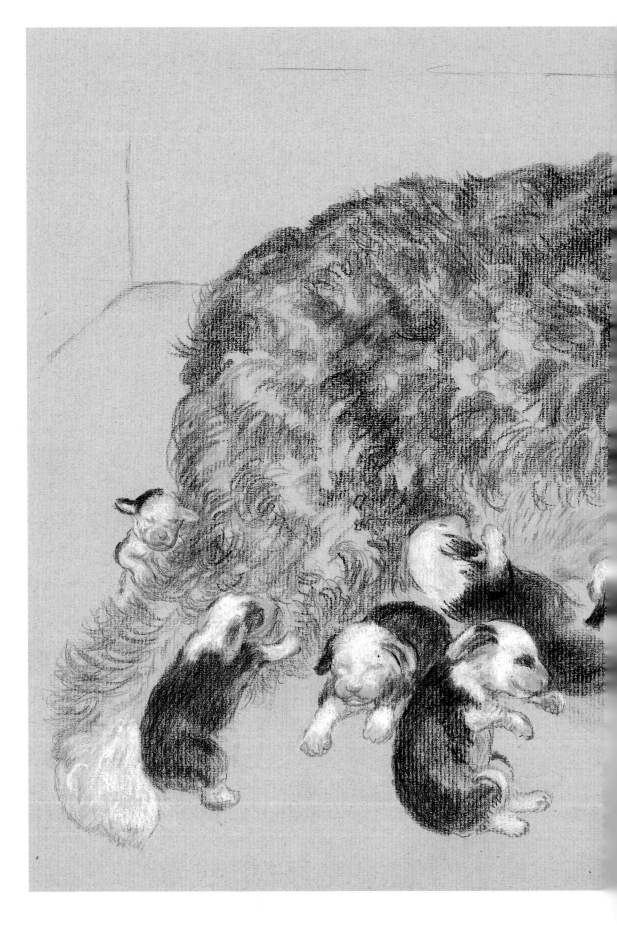

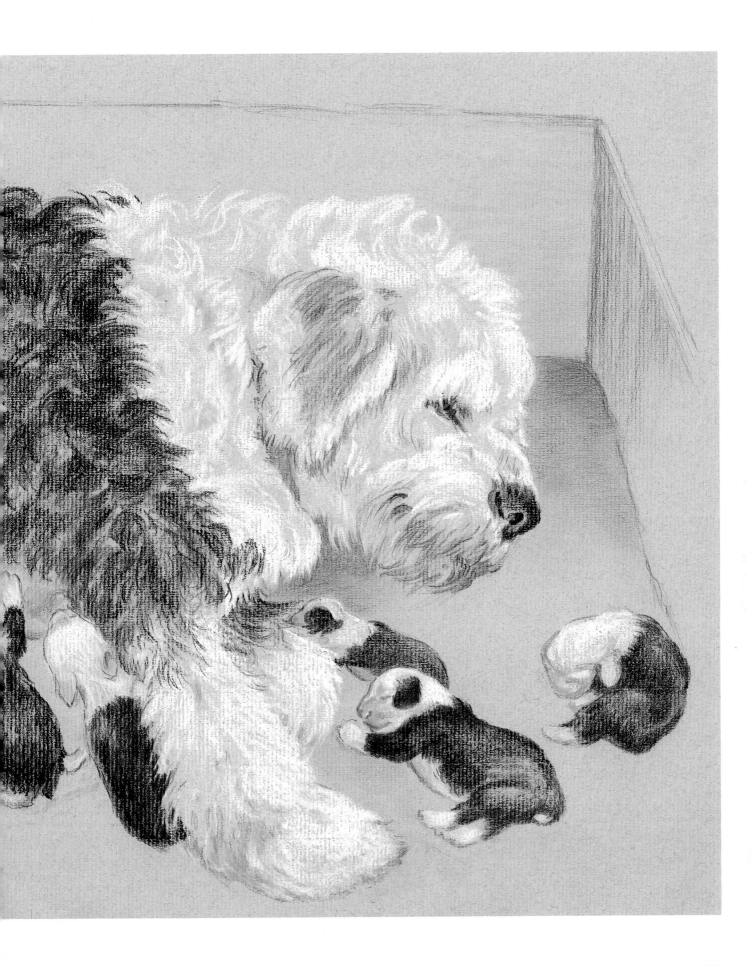

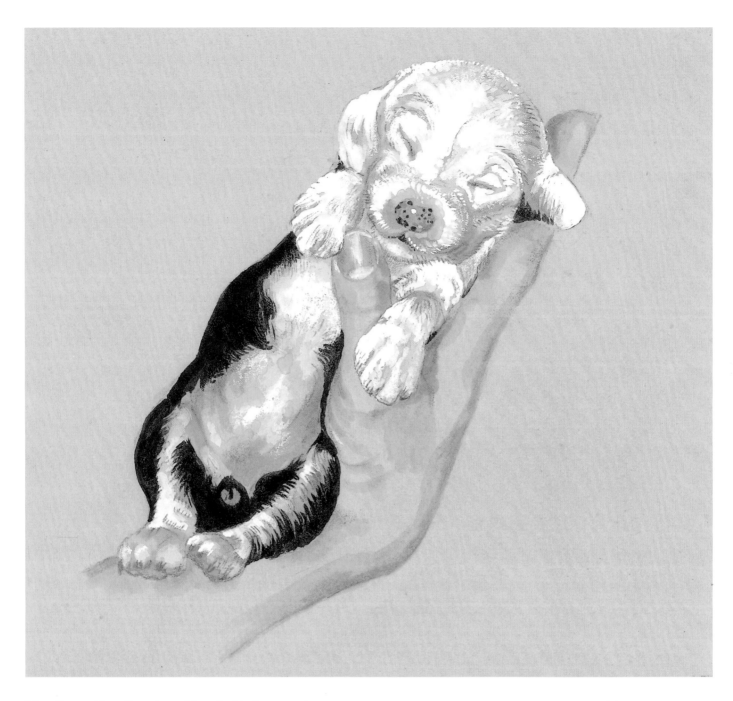

After-dinner Nap. *Gouache and broad-nibbed pens on Mi-Tientes paper, actual size of original.*

THE OLD ENGLISH SHEEPDOG

This ever-popular breed is worthy of a prolonged study in its various phases of development in which the quality of fur as well as its colouring changes quite considerably. Those cuddly contours belie its size and strength and the fact that it is not only a lovable family pet, but also a formidable guard dog, originally used for guarding cattle. Despite the toy-like appearance, different individuals vary as much in their temperaments as any other breed, and the apparent friendliness of that bouncy bundle of fur bounding towards you should never be taken for granted!

Their abundant charm is evident at birth as can be seen in the close-up picture as well as on the two preceding pages. This mother considered me as one of her trusted friends and was only too eager to show me her accomplishment proudly. After a discreet initial approach on my part, I was able to sit right by the whelping box and peer over its edge at the new arrivals.

Drowsy contentment is soon replaced in a month or

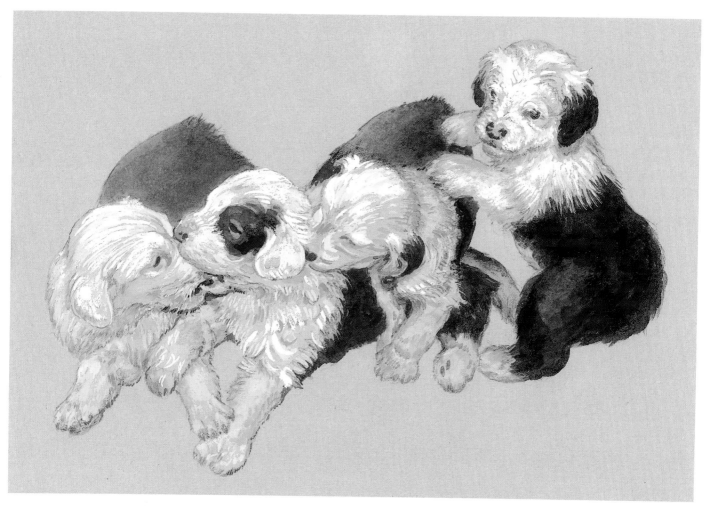

Month-old puppies in a tug-of-war! Painted in the same combination of mediums. 152 × 216mm (6 × 8in).

so by rowdy games in a squealing tangle of legs and jaws. At this stage, their likeness to panda cubs is most obvious with the absence of tails, and distinct patterns of black and white, especially in the case of those that have black eye patches, which are often described as 'panda', or 'half-panda' if they only have one.

In the above illustration, I applied light and dark greys first with broad-nibbed pens and added gouache on top to define the fur texture. The pink tones are still in evidence on faces and paws, and even in older animals there is usually a tinge of pink around noses

and eyes giving them a rather endearing, immature look. Although the general colouring is basically black and white in the various puppy stages, there are subtle mixtures of tones in the shadowed areas of white, which you can capture on tinted paper, using the colour of the paper itself combined with light applications of gouache, coloured pencils, or a blending of both, emphasizing the pure white parts.

In these examples of the Old English Sheepdog, I have used different shades of tinted papers to show a variation of effects, letting the background colour

Youngster at three months, using broad-nibbed pens, coloured and chinagraph pencils. 145 × 195mm (5¾ × 7⅝in).

work for me. The portrait above is on blue-grey *Ingres* paper; I used a blue-grey and a darker grey *Pantone* pen first, then worked black pencil on top with some dark blue in the eyes, and used pale grey, yellow brown and pink for the light fur. I added the pink over heavily applied white chinagraph to give it a softer look.

This puppy has the typical 'panda' type of markings and at this stage is becoming noticeably longer haired, making it more difficult to define the form underneath, and as the coat reaches its luxuriant length and density it will be increasingly so. There is also a drastic change in the colouring of the dark areas which, in the young adult, gradually become lighter. Some even appear to be almost entirely white for a time, reverting to black or dark grey later. If clipped short, as is the mother with her pups or the one in the painting on page 33, the hair is not so much of a problem, but the fully grown length can be very bewildering at first. A thorough study and understanding of the breed through careful observation and numerous sketches are essential.

The greetings card with three dogs was done for an organization devoted to the care of unwanted dogs and strays whose apt slogan is – 'A dog is for life . . . not just for Christmas'. I had the idea for a combination of contrasting types of breeds interacting with each other, and imagined the probable sequence of events if they were left to their own devices on Christmas Eve with a stocking full of gifts for each to investigate.

I chose a grey mounting board with a slight, green tinge to enhance the strong reds and bright decorations and enable the tree to fade out gently at the top of the composition, its branches being near enough to the background colour to avoid an abrupt division. The Yorkshire Terrier and Old English Sheepdog stand out well against it, but the problem was to make my black Great Dane do so as well, as it was important that he should be prominent in the forefront of things, as he always is in reality! The solution was to exaggerate the highlights on his shiny

Greetings card. Gouache on coloured mounting board.
305 × 381mm (12 × 15in).

coat slightly using a very pale grey with a touch of ultramarine blue and violet, fading other parts of the figure to give it more perspective.

One of my models was 'Sappho', mother of the litter at the age of thirteen months, her hair secured by a slide above her eyes, and long 'tresses' in disarray. There is nothing more delightfully entertaining than the sight of one of these dogs having a really abandoned romp, looking like a ribbon-festooned dragon in a Chinese New Year's procession, who, for a grand finale, flings itself into a large armchair in an animated and confusing heap of fur!

Such a dog makes a striking contrast to its show counterpart – having been groomed for four to eight hours before a show. After its hair has been washed, dried, combed and brushed, it is dramatically transformed to an airy, candy-floss confection as seen in the examples shown here.

Ready for the show ring. Pen and ink design for T-shirt.
267mm (10½in) square.

The pen and ink version above was made for a T-shirt design, and, like the grooming itself, drawing it was also a painstaking process! Both figures are facing to the left as this is the side from which they are traditionally judged as they parade anti-clockwise around the show ring.

JORDON

Jeddep High Image ('Jordon') gouache and pencils on Mi-Tientes *pastel paper. 322 × 350mm (12¾ × 13¾in). Hair is pinned back to show the eyes.*

The painting is of an eighteen-month-old dog with its characteristic light grey hair. I had to take particular care with neutral shades of grey as the blue background tended to give them a faintly orange tinge, so I used quite a lot of blue in this area.

Sadly, the need for grooming this luxuriant coat, if only to keep it clipped and in a clean, untangled state, is often neglected. All too frequently these lovely pets end up homeless or maltreated through ignorance, thoughtlessness or callousness. They are not only difficult to look after properly, but from the artist's point of view, the challenge to do them justice is also considerable, though well worth the effort.

GREETINGS CARD DESIGN IN FOUR STAGES

A preliminary drawing, preferably in colour, is
essential in planning a composition. Having first
worked out the concept, you should put it down on
paper in as quick and convenient a way as possible. I
used coloured pencils combined with felt-tip pens for
this Christmas card 'rough', which was sufficient to
put my thoughts into a concrete form. I didn't alter
the enlarged drawing, except to make the settee
somewhat higher and therefore have the small dog
stretch forward still further, which proved much more
effective. The importance of getting the drawing of the
figures absolutely *right* cannot be overestimated. At
the same time, their attitudes need to be positively
conveyed by their positions as well as their
expressions – the Dane's, jealously protective of his
new acquisition – the smaller dog's, eager and
inquisitive, straining as near to the prize as prudence
will allow.

Everything about a Great Dane must be described in
superlatives. Its legs, body and tail are *very* long –

*Preliminary sketch using coloured pencils and felt-tip pens in the
same size as greetings card, 114 × 164mm (4½ × 6¾in).*

Below: *Drawing enlarged up to size of painting, 266 × 381mm
(10½ × 15in) with alterations to settee and dog on right.*

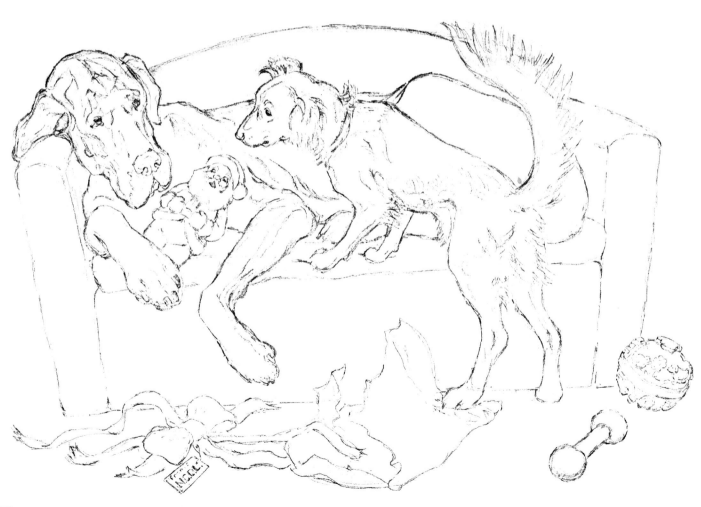

70

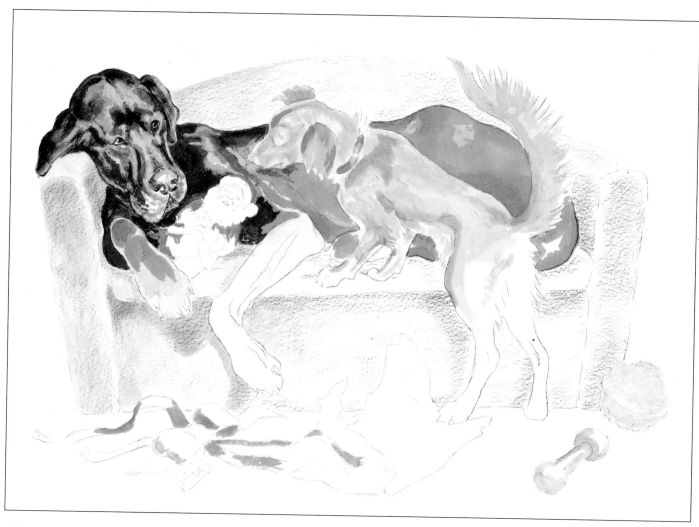

Painting in progress with main colours thinly applied.

neck muscles, *extremely* powerful – paws, *huge* – head, *massive*. No wonder the breed is known as the 'Apollo of dogs'! With all these things on such a large scale, it is not an easy matter to portray these qualities in their true relation to each other. Despite the many times I have drawn him, I often ask myself: are those legs long enough – the paws sufficiently large – the head both broad, and at the same time, long in the muzzle – the nose proportionately large? The answer is often, No!

One item which can be surprisingly useful, is a mirror when drawing. Suddenly seeing one's work in reverse seems to accentuate the slightest mistake in draughtsmanship. I have also found it invaluable when working on sculpture, placing it behind a figure so that I can see both sides at once.

Whenever possible, I use something in a composition featuring a very large dog that will serve as a term of reference – if not a smaller animal, then some familiar object whose size is immediately

identifiable. The toys in this one had to be fairly big, not only as suitable playthings for a 'gentle giant', but also large enough not to appear insignificant in the picture. The idea came to me while watching my Great Dane with a young and cheeky canine neighbour, and observing his anxiety to keep all his playthings beyond her reach, including those he had not played with for weeks!

The small settee helps to show off his size, and the golden coat of his companion contrasts well with the glossy black sheen of his. I put a thin wash on it first with a mixture of grey and a touch of ultramarine, then a darker grey, most of which will be filled in with black, leaving a small space for the pink inside the ear and the warmer grey of the silvery muzzle. I then used the side of a dark green pencil point to give the fabric a distinct texture, using the rough surface of Langton watercolour paper mounted onto board, though the paper is really heavy enough to use on its own. I rubbed the pencil in, applying a wash of pale green over the top, the softer effect already being noticeable on the left side in the earlier stage. The

The Favourite Toy painting completed. Gouache and coloured pencil on Langton watercolour paper in a combination of opaque and transparent techniques. The pose of my Dane was easier than most as he spends a good part of his day lolling about on a similar piece of furniture.

smaller dog is washed over with light yellow ochre and pale orange, shaded with Raw Sienna and here and there a touch of Vandyke Brown. Before carrying on any further, I filled in portions of the ribbon and toys to establish these four colours in relation to that of the dogs.

Next I built up the Dane's head defining the highlights more sharply and accurately with grey-blue, mixed with white to make it opaque and therefore capable of covering darker greys and blacks where appropriate. The effect can be seen in the finished version, though the sheen is noticeably more subdued in areas directly behind the other dog so that her outlines are more pronounced. Against a light background, she would have been lost, and I arranged the principal figures in the picture so that both animals, despite their disparity in size, would stand out equally well.

Much of the effectiveness of a composition involves this sort of planning. I never begin a painting involving several elements until I have worked it out completely, with the exception of small details, and can visualize the finished product.

CÉCILE CURTIS

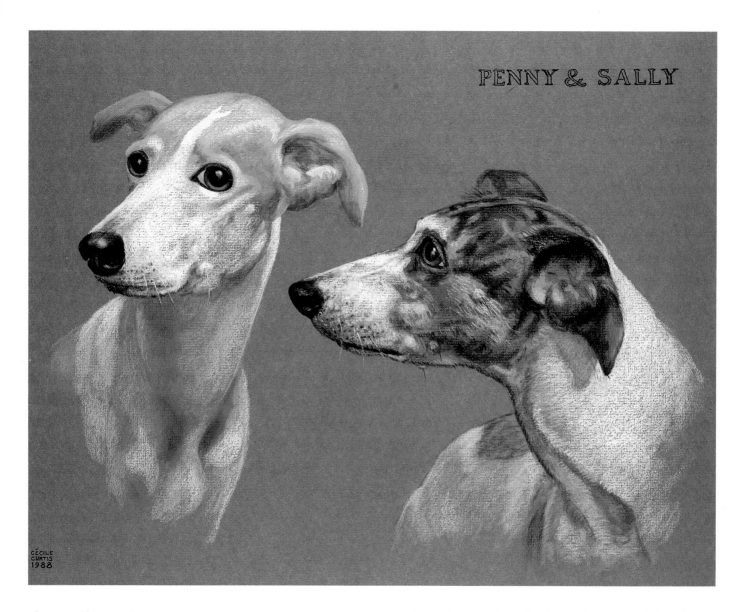

GREYHOUNDS – THE OLDEST BREED?

The elegant sleek silhouette of these graceful animals has not altered from those found in pictures on Egyptian tombs of 4,000 years ago. Their short-haired coat and streamlined contours make them ideal for studying a dog's bone structure.

These two family pets were formerly racing greyhounds adopted through an organization dedicated to finding homes for retired racers.

I chose a dark background for this portrait, both dogs being predominately white, to give dramatic contrast. The more recent acquisition on the left with fawn markings, is shy and timid while her companion is self-assured and outgoing, so my first consideration was to convey this in the attitudes of their heads and expressions in those beautiful, large eyes and delicate faces.

Greyhounds. *Gouache and chinagraph pencil on Mi-tientes pastel paper. 292 × 381mm (11½ × 15in).*

I sketched them in lightly with a white pastel pencil plus black and brown, adding gouache quite thickly. I then built up white areas of the coat with chinagraph, letting the colour and texture of the *Ingrés* pastel paper come through. Note the difference in grain between this, the *Langton* watercolour paper on the previous page, and *Mi-Tientes* in the Old English Sheepdog portraits on pages 33 and 67, which both feature mainly white animals.

FELINE STUDIES

You will soon discover that drawing a cat is as deceptively simple as the animal itself – its structure subtly hidden by soft fur and, like its moods, indefinable – quite unlike a dog, whose eyes, as well as attitude of body, tell you so much in a straight-forward sort of way.

The following pages show a variety of colourings and their treatment against different backgrounds. This example seemed best suited to being placed against a brightly patterned cloth, which shows off the odd division of black and white. The harlequin effect of a white patch on one side above the mouth and the opposite on the lower, gives the face character and individuality.

As with most black animals, the fur that seems to be a solid mass of black, after careful study reveals a variety of subtle colours – pinks, browns and blues, the latter often being exaggerated in photographs, particularly those taken with flash. These changes in colour are not obvious – you really have to look for

Tom. Mixed media on watercolour paper. 228 × 317mm (9 × 12½in).

them. I used a mainly watercolour technique, augmented by broad-nibbed and brush pens. The rose-coloured background on the cloth was applied with a broad nib with two or three further applications for the shading. Only the eyes needed an extra clarity, which was added with a touch of Linden Green gouache.

Rough preliminary sketch. Note rectangle surrounding figure has been adjusted slightly to the left and downward.

The choice of background colour for this feline was *Mi-Tientes* 'Havana' to bring out the white on the frontal areas and legs while blending with the reddish tones on the upper parts.

Being a bit of a wanderer, 'Ginger' had to be stalked by his owner through all his favourite haunts in the neighbourhood and, after an hour or two, a 'phone call assured me a 'sitting' was possible. He condescended to remain at home long enough for me to study him and eventually take photographs in bright sunlight by a kitchen door. Having decided on the angle I wanted, his attention was held by the prospect of being fed small tidbits as I took nine shots of him from which I later selected the best aspects of each for the drawing.

Even though there is only one element in this picture, I made a small preliminary sketch to ensure that the figure was placed in the best position – head not too far off centre and a reasonable space around the outside.

An easy way to enlarge a picture is by using a centimetre ruler together with an inch scale divided into tenths so that for instance, 3.6cm = 3.6in, the

sketch being a little less than one quarter of the enlargement, with both divided into four parts in the usual manner. To avoid any inadvertent change in the angle of head and eyes, which is often an important feature, I placed a ruler across the pupils, marking its position on either side of the sketch, then measured the distance from the top to where it intersected the sides, translating this information to the enlargement.

Having established an accurate drawing in pencil, I filled in the white areas lightly using a normal type of white pencil that stood out sufficiently well on the dark paper. Then I started the darkening of the area behind the head and back with three broad-nibbed pens of varying intensity, not only to see the overall shape becoming more visible, but also in order to extend hair and whiskers over this at a later stage.

As with any animal portrait where I always look for even the smallest individual traits, I indicated without undue emphasis, the small nick in the cat's left ear.

The materials used here are limited to broad-nibbed pens, coloured pencils, and finally, a white chinagraph pencil. Only the pink tinge on the top edges of the ears and yellow-green in the eyes were later heightened slightly with gouache to make them sharper. All the rest being fur, it was left with the soft effect produced by the sides of pencil points against the coarse-grained surface.

Ginger. Broad-nibbed pens and pencils on Mi-Tientes paper. 355 × 280mm (14 × 11in).

CÉCILE
CURTIS

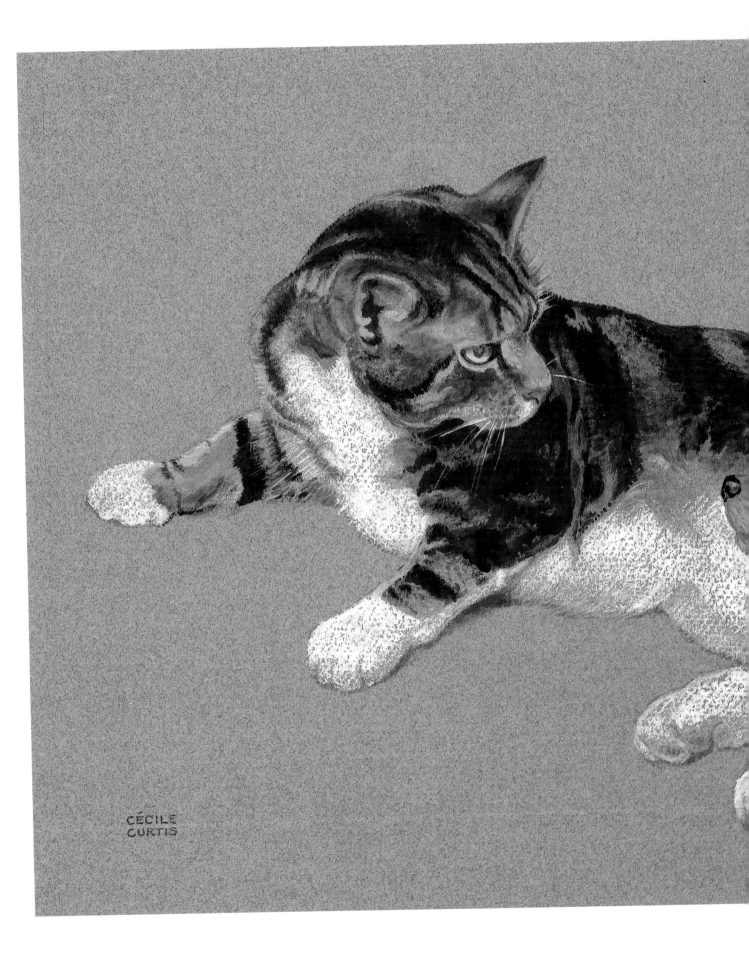

CÉCILE
CURTIS

CAT AND DOG

The expression 'they fight like cat and dog' is strangely out of place in the presence of some firmly-bonded pairs like the ones opposite and on the preceding pages where the incongruity of the tiny 'Yorkie' in combination with the large tabby cat had amusing pictorial possibilities, and the title of the well-known Victorian painting by Sir Edwin Landseer comes to mind.

'Smartie' the cat shows amazing tolerance to 'Scruffy' who is always the playful aggressor despite her exceptionally small frame and the fact that she is slightly lame. The warm grey background seemed the most suitable to show off the variegated colouring of the cat, placing the dog in just the right location against the dark areas of the cat's fur behind the dog's head where it caught the most light, and the white part accentuating the shaded section underneath.

The Yorkshire Terrier was painted entirely in gouache just as she was in the earlier pictures on pages 32 and 33 between the paws of her large canine companion.

The more restrained colouring of the cat is rendered with a mixed media technique using broad-nibbed and brush pens plus coloured pencils, touches of gouache around the face and a chinagraph pencil for a crisp definition of the white fur.

The two had to be studied separately, as *nothing* would persuade them to approach each other as I had seen them before for a fleeting moment. I had to resort to checking their relative sizes with a tape measure.

Dignity and Impudence. *Broad-nibbed and brush pens, gouache and pencils on slightly mottled, warm grey pastel paper. 255 × 381mm (10 × 15in).*

Sleepy Sheba *sketch from life, same size as original.*

'Sheba', a *male* cat, and 'Sally' have spent the better part of seven harmonious years together, but two other cats who live with them do not share the same close relationship with the dog as Sheba does. I was asked to paint their portraits after they had both become seriously ill, although their bright, contented demeanour did not convey this.

Before starting work on the painting, I made different combinations of the figures in very small sketches, each animal having been done separately several times on pieces of tracing paper, and then put them together until I finally decided on the one which suggested their fondness for each other without appearing too contrived. This meant posing and

reposing them until they both became quite vexed with all the fuss, so that I would have to wait while treats were being distributed to each one of the four animals, and then start all over again!

I chose a background which would blend with the colouring of both subjects and also serve as a contrast for the very dark as well as very light tones. This was darkened still further around the cat to set off his pale and delicate topaz fur.

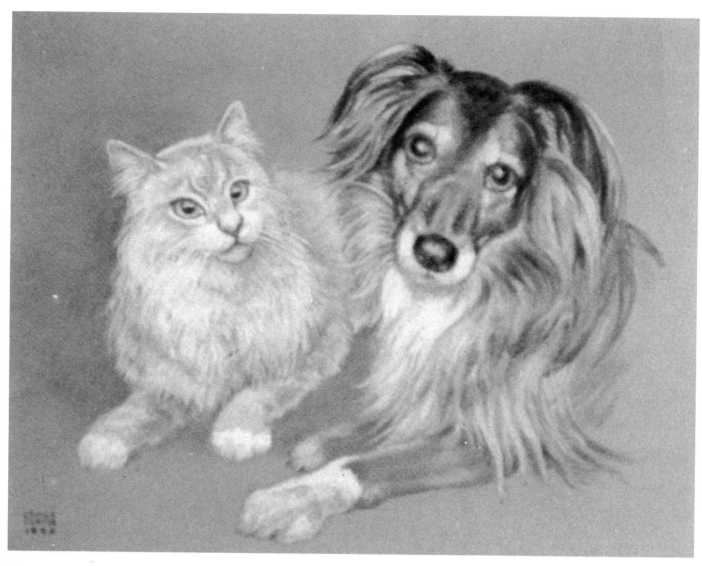

The Best of Friends. *Gouache and pencils on Mi-Tientes paper.*
267 × 343mm (10½ × 13in).

TALKING BIRDS

Of all the birds which are kept as pets, the three members of the parrot family opposite are the most familiar amongst the talking varieties. Their ability to speak has made them popular since Roman times, although they actually only imitate the spoken word through a voice box, which, unlike ours, is located at the *base* of the windpipe. Like ventriloquists, they are able to talk with the beak closed, the upper one being characteristically curved, fitting over the lower mandible. They also use their beaks to grip when moving through trees or a cage, and their feet can hold food up to the mouth, except in the case of budgerigars. All the members of this group possess four toes, two pointing forward and two backward, providing a firm grip on a branch or perch. Another advantage is their longevity, a few individuals from the larger species reaching the remarkable age of 80 years.

Their brilliant plumage makes them attractive subjects to paint, but a newcomer must beware of that useful beak, which is also quite capable of cracking a human finger as easily as a Brazil nut. Studying them from a discreet distance is definitely recommended!

TECHNICAL APPROACH

In this composition I have shown them in their relative sizes, taking into account the distance between them, with the smallest in the foreground. 'Almond green' *Ingrés* paper seemed best for a rain forest habitat, which I only lightly suggested in the background with subdued colouring to highlight the brilliance of the birds that are painted in gouache, with mainly pure colour from the tube. I used a mixture of black, white and red ochre for the beaks and feet of the two larger ones, omitting black in those of the much paler budgerigars. I also had to make certain that the various barks of trees and liana vines were a different colour to the birds perched on them.

When painting birds, it is tempting to try to define every feather which seems particularly prominent, but you will soon discover that this can be a great mistake, giving a false impression of the form underneath and losing the effect of light and shade.

THE MACAW

This South American breed is probably one of the most spectacular of birds, not only for its exotic colouring, but also for the exceptionally long tail which comprises two-thirds of its total length of 86cm (34in). I have chosen the Blue and Gold, being the more familiar version of many vivid colour combinations. It has a green 'cap' and predominately white face, which one discovers on closer examination is really wrinkled white skin with a pinkish cast in parts. An amusing trait of the males, similar to that of the Agama Lizard's, is that, when excited, they blush a livid pink! The uppermost side of their body and wings are turquoise and ultramarine blues, which I have interpreted with small additions of white added to them in the sunlight, while chest and undersides of the wings are a startling contrast of golden yellow.

I once spent a week with some friends in their country house, which was also occupied by several German Short-haired Pointers and a pair of these magnificent birds. As we sat beside an open fire, they made a memorable picture, casually walking across the sleeping dogs stretched out, impassively, in front of it.

My model for this painting was a fine female specimen, suitably named 'Mrs Mac' who lives in an ideal environment in the countryside where she enjoys total freedom. Happily, she is never tempted to fly beyond the confines of the tall trees surrounding her home and, no doubt, provides an astonishing spectacle to many a passerby.

Talking Birds. Gouache on pastel paper. 350 × 280mm (14 × 11in). The darker tones in the background are done with broad-nibbed and brush pens in similar colours.

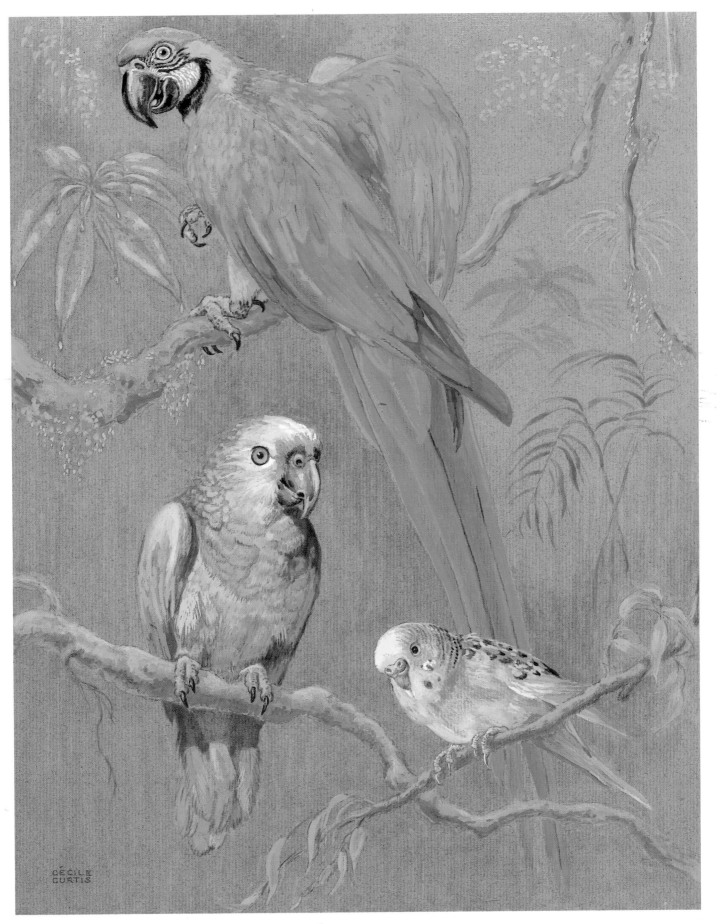

A rough preliminary drawing on the same paper, half the size of the finished painting in which colours are only partially filled in. I originally planned the parrot eating a peanut held in his foot, but this seemed to distort the figure too much.

THE PARROT

Another native of South America whose colouring rivals that of his companion, if not in such sharp contrast, is even more varied. This is one of twenty-five types of Green Amazon, which, at first glance, appears to be entirely green except for small areas of white, yellow and turquoise blue. With only a slight movement, however, bright red feathers are visible, tucked away under the wings and short, stubby tail. Further observation shows tinges of the turquoise also invading the green of the chest, none of which would be immediately evident on short acquaintance or indeed, in most photographs.

It was most important for me to try to locate accessible examples of all these birds, although I had almost given up hope of finding anyone who owned a parrot in the vicinity. Then unexpectedly, I saw 'George' opposite a small nearby park, sunning himself on a perch outside the 'Cosy Café' where customers are regularly entertained by his conversation. Although untethered, he never leaves the premises and during closing hours flies in and out of the café at will. I arranged with his owner to visit him at this time and, equipped with a few peanuts, I spent an hour of so studying, sketching details and photographing him, during all of which he remained totally silent.

Contrary to popular notions, these birds do not necessarily utter words 'parrot fashion', but often associate them with specific events or even individual people, as would a two-year-old child.

Having gathered my things, after a backward glance, I slowly walked away and was rewarded with just one utterance: 'Good-bye', said George.

THE BUDGERIGAR

The smallest member of the trio, unlike the other two, originates in Australia and is the most popular of all household pets. Its coloration is also exotic, and zealous breeders have added several permutations.

Mature males are distinguished by a blue 'cere', the part above the beak around the nostrils, whereas the female's is brown. Each one's colouring varies considerably in its distribution as well as the markings around the neck, called a 'bib', and the characteristic striations, or stripes, around the head are more pronounced in some, so that there are no two exactly alike. In my original painting, 'Harry Hall' is life-sized in order to define these individualities. He was first taught his name and address in case he should accidentally venture into the outside world, and can now talk for hours without repeating himself!

PORTRAITS OF PET BIRDS

Paintings of birds are extremely popular, the subject matter being undoubtedly very decorative. It is one thing, however, to depict them in an attractive, as well as zoologically accurate manner, but to capture an individual, you must study thoroughly its distinguishing, and possibly well-hidden, characteristics. You may achieve a reasonable interpretation of the bird without having captured those points which its owners knows only too well.

With other pets, especially a dog, where you can capture a particular expression or attitude, a portrait is very much easier.

DOWN ON THE FARM

Barnyard Birds. *Mixed media on light hemp-coloured Mitientes paper. 153 × 203mm (6 × 8in).*

Another interesting as well as varied source of subject matter is a farm which contains animals. Lamentably, many of these now employ factory farming methods and would therefore not only be inappropriate, but unwelcoming to the casual observer. Fortunately, there are still some 'free-range' farms left, and if you gain permission to visit one, the experience will be both rewarding and muddy where some sort of sturdy, waterproof footware is definitely a must!

CITY FARMS

Of course, as most people live in the suburbs or the city, a visit to a farm might be impractical. There is,

however, a splendid alternative, if not in such attractive surroundings. This is the innovation of City Farms, run by local communities, usually on derelict land. Their purpose is not only to provide education and leisure facilities, but they are also a means of introducing people to animals which many may never have seen 'in the flesh' before, certainly not within touching distance. It is a wonderful opportunity for everyone, including the artist.

The drawings here and on the following pages were done at Mitcham's Deen City Farm, my nearest source of a barnyard atmosphere. The first of these is of two familiar fowl, showing a defiant goose facing an obviously intimidated chicken. I sketched them separately initially, combining them afterwards in their humourous confrontation, using coloured pencils

Anglo-Nubian Goat. *Pencils on Ingrés, 'Havana' paper.
204 × 270mm (8 × 10⅝in).*

and a little pen work on a pale tint, though just
sufficiently strong to show the white chinagraph
against it.

The unusual Anglo-Nubian together with the
Toggenburg Goat were sketched on the spot with
black and brown plus a mere flick of yellow for the
eyes. The white was indicated with a pastel pencil on
top, to which I added chinagraph later to prevent
smearing.

These animals enjoy a good life being fussed over
by the crowds of school children who come to see
them, and producing kids as well as quantities of milk.
They also earn their keep by cropping overgrown
lawns and fields, including those at the local vicarage,
accompanied by a few sheep, the latter devouring the
grass, and the goats, just about anything! These tasty
meals of fresh greens are a rare treat and welcome
change from their usual farm fare.

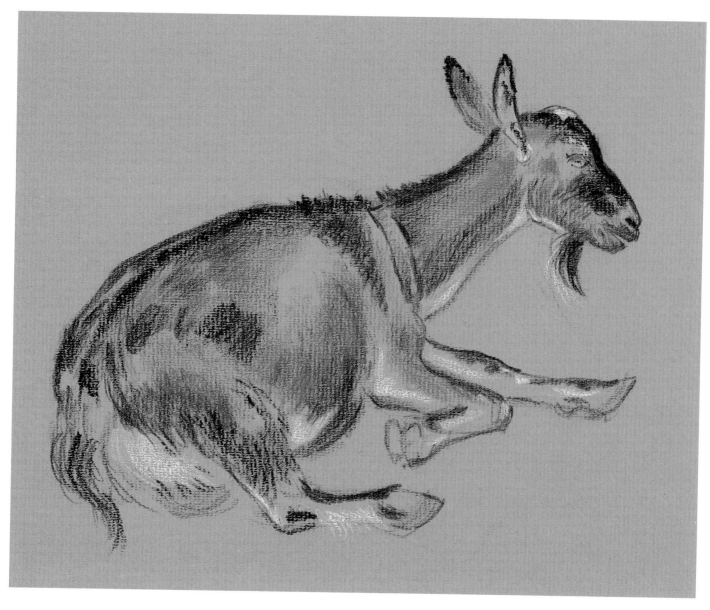

British Toggenburg Goat. *Pencils on Ingrés, 'Sienna' paper.*
190 × 234mm ($5\frac{3}{16} × 6\frac{3}{8}in$).

If you are planning a trip to a city farm, check with the manager first, and plan to go on a quiet day when you won't be in the way. It is also sensible to limit your drawing equipment to the basic essentials just a few selected coloured pencils, brush pens and, at most, a medium-sized spiral sketch book. Working on a larger scale with room to swing your arm, producing long, flowing lines on a big area may prove something of a liability in these circumstances. Photographs taken in a good strong light can help, if you want to capture a lot of detail and texture of the special breeds of poultry, rabbits and goats. Do watch out for your sketching materials, however, when working close to hungry goats!

Many city farms have several types of grazing animals, cows and sheep as well as horses, but remember that in bad weather, they usually prefer the shelter of their quarters, even if you do not. On their rest days, horses and cows and even the sheep, may be taken onto adjacent fields where your presence might be a hindrance.

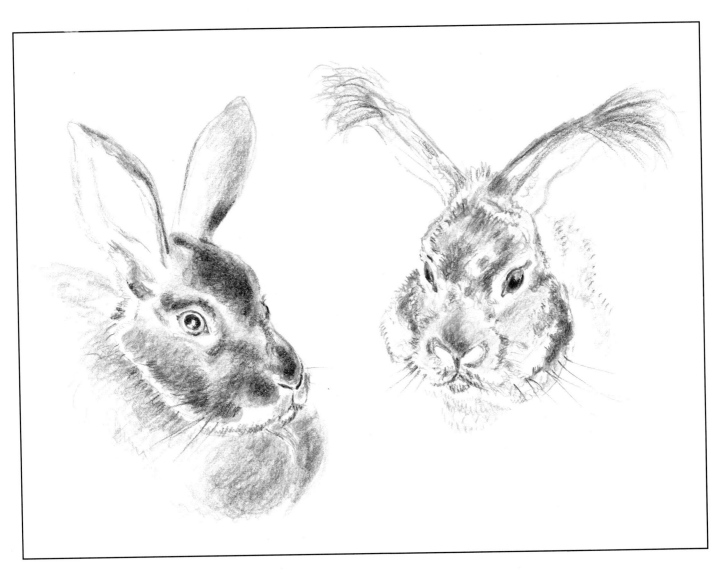

Pencil sketches of Polish Chocolate Rabbit and a lop-eared variety. 190 × 254mm (7½ × 10in).

Although they are sometimes difficult to see in their hutches, the different breeds of unusual rabbits are also fascinating. I made the above sketches without much light, using a very soft black 6B pencil as well as a grey one. The Polish Chocolate on the left is a magnificent specimen, and the lop-eared variety on the right looks like something out of Walt Disney! I was told he was not at his best, as his floppy ears were showing signs of moult, but I found him irresistible, nevertheless.

EQUINE STUDIES

Besides farms, riding stables will provide plenty of subjects for artists. Although they get adequate exercise, these animals are not overworked, each putting in about three and a half hours per day, and are given one day off a week to graze in the fields. During their rest periods in stable or field or better still, when they are being groomed, there is plenty of scope for studying them.

Sketch in coloured pencil of grey mare and foal. 241 × 190mm (9½ × 7½in).

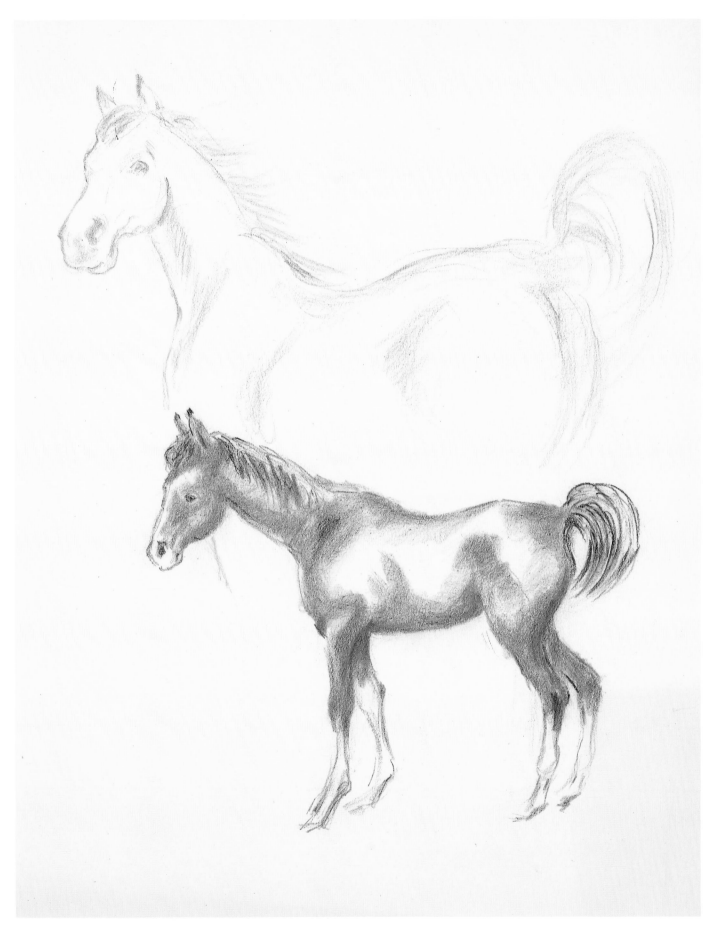

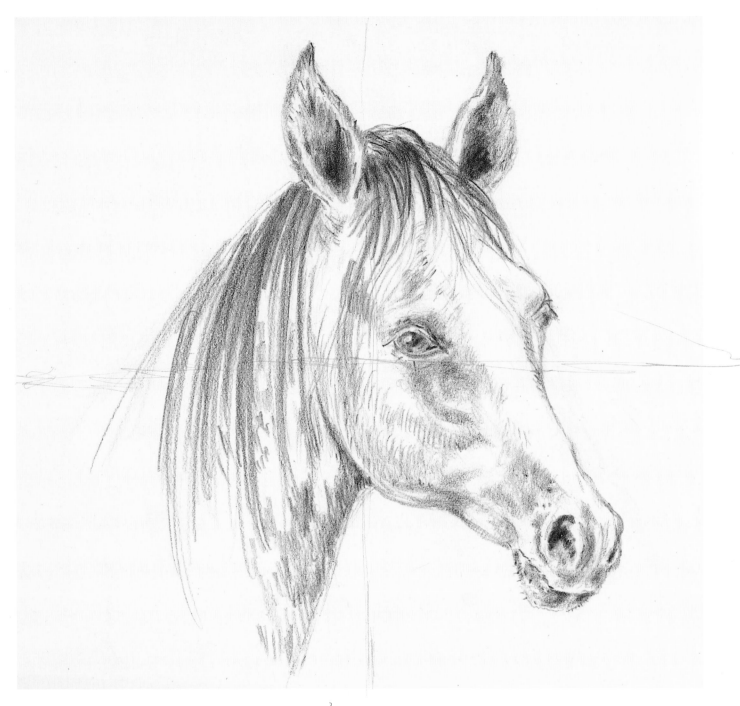

Some really fine specimens may also be seen at horse shows while the entrants are waiting 'back stage' to make their appearance in the limelight. This Arab Grey example attracted me with its delicate head and beautiful eyes. The larger show jumper opposite was the famous 'Merely a Monarch'. A sepia pencil sufficed for the grey, and I used two shades of brown for this one.

Behind the scenes at a horse show. Two pencil portraits slightly reduced, plus a lightning sketch.

A word or two of warning: be prepared to stand while working, and to move out of the way quickly!

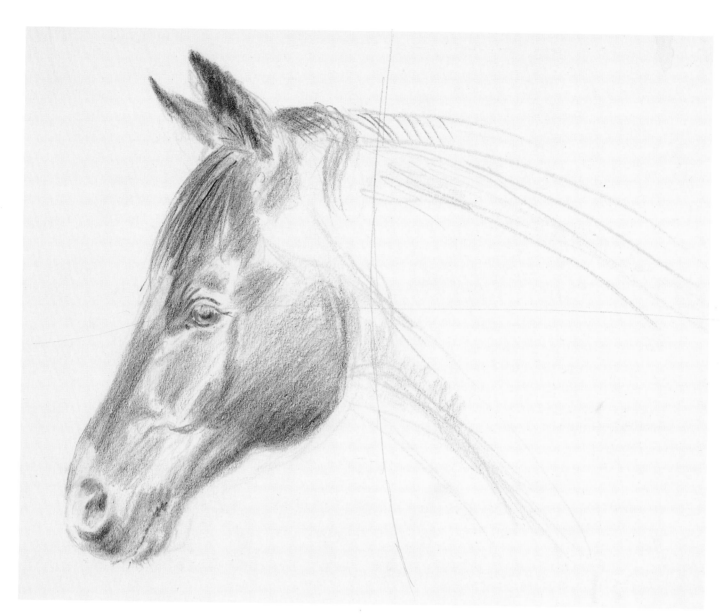

A PET PIG

No group of farm animals would be complete without the inclusion of a pig. Having heard of someone who kept one as a pet, I seized this rare opportunity to visit Penny, the owner, in her beautiful surroundings in the Surrey countryside where I was not only introduced to her unusual pet, but a vast and amazingly diverse collection of all sorts of mammals and birds. Besides dogs, chickens, swans and ducks, there were wild species such as Arctic foxes, exotic birds, including owls and parrots of every type, plus the aforementioned 'Mrs Mac', the Macaw. It took quite a while even for a rapidly conducted tour of the grounds, which contained row after row of beautifully constructed quarters, without sufficient time to see all their inhabitants. Most of the residents, the pig included, had been rescued from an unfortunate fate of one kind or another and I could not help but be filled with wonder and admiration that one person was caring for all of them.

Eventually we came to an immaculate and solidly-built little house with a small front yard – not the sort to be blown in by a huffing and puffing wolf. Here lived the object of my visit, a female pig, inexplicably named 'Ralph', who emerged from her home with its cosy bed of clean straw when called. Seeing we had no food, she soon retired once more to the darkness of the house where there was just enough room for her considerable bulk. This situation was soon remedied by a few farmhouse loaves, and, having given most if it to her, I tucked one under my arm and started sketching. It was a nearly disastrous mistake. Without warning, she suddenly lunged over the top of her enclosing fence in an attempt to help herself to the remaining loaf, my sketch book, and anything else that got in the way! I stepped back and narrowly missed sliding down into thick mud.

When I asked if she was allowed to roam at will, her obliging owner opened the gate, and 'Ralph' shot out with the speed of a gazelle, disappearing into the distance. A loud and unidentifiable noise followed this somewhat alarming event, and I asked Penny what it meant. 'Bliss – just sheer bliss', she replied.

After following my elusive model around with some difficulty whilst she rooted through items that had been gathered for a bonfire, Penny lured her to a grassy area near the house with a bucketful of luscious apples, allowing me to observe her in more tranquil conditions.

In this study of her sniffing the unexpected feast, she has the same look as when I first saw her as she caught a whiff of the bread – eyes ecstatically closed and lips smiling with satisfaction, emphasized by the white whiskers beside her mouth. I wanted to feature the effect of the sun catching the wisps of hair around her head, also using this lighting to highlight the apples. I chose the yellow variety and was careful to avoid the same colour anywhere else in the composition. The tint of the paper was just right for her body in shadow, which is given form by pink and violet broad-nibbed pens, and the remarkably silky-looking hair drawn over it afterwards with pale grey, pink and mauve pencils. Last of all, I used white gouache mixed with a touch of yellow to intensify the sun-lit hairs and pure lemon yellow on the apples. Other than the tip of her nose, plus a few flecks of light on the rooftop and tree trunks, the rest is done entirely with the pens and pencils.

Remember when you use these pens on tinted backgrounds, especially the lighter shades, the colour changes and unless it is one which is near to it, also becomes greyed. However, you can turn this to advantage in some instances and, if necessary, achieve a brighter tone by repeated applications.

Undoubtedly, the picture's main points of interest are the animal's expression and a more unusual setting than a barnyard locale. I constantly look for just this sort of combination whenever circumstances permit.

Penny's Pet Pig. *Mixed media on Mi-Tientes 'Cachou' paper. 292 × 228mm (11½ × 9in).*

Ms. Ralph, keeping an eye on my sketch book. Reproduced in the same size as the original.

Opposite, *Two-colour scraperboard illustration of* Common Seal with Mouse, *one half the size of original.*

WILDLIFE

MAMMALS

Grey Seal Family. *Watercolour on illustration board. 215 × 330mm (8½ × 12in).*

AQUATIC ANIMALS – SEALS

The sea is not a habitat that one immediately associates with mammals, but there are quite a few species who live there for some, if not all, of their lives. One of the more familiar and cuddly inhabitants is the seal. The grey variety differs only slightly from the common seal: the former is one and a half times as large as the latter, with the male measuring three metres (9ft) or more in length and the females, about 3 metres less. The painting above shows their colour differences as well as that of a newborn pup. They are also distinguished by long, 'Roman' noses whereas the common seal has a more retroussé nose.

Watercolour was the most suitable medium for interpreting the subtle changes in the mother's fur as the dark, irregularly-shaped spots gradually blur into a solid grey on the head and back; the male's coat, which appears mainly black, has lighter blotches in the dark fur. I painted the markings first, washing over most of them with darker tones. Interestingly, the front flippers resemble hands when they are grasping an object, with a fifth finger instead of a thumb.

Like all pictures featuring wildlife in their habitats, everything included in the background has to be carefully researched in addition to the physical details of the animals themselves. I selected the twisting fronds of seabelt which grows to great length and profusion in the water, plus the much smaller, greenish bladder-wrack whose dry air bladders pop when pressed, and added a few barnacles to the rocks

Preliminary pencil drawing for a tea-towel design in scraperboard of two dolphins. 350 × 260mm (13¾ × 10¼).

CÉCILE
CURTIS

by the small pond. The green growth on the nearest rock promontory is sea campion, a common wild flower of the coastline, not that much detail can be seen, even in the original, but you should always make sure that what you place in a given setting *could* be there.

The painting was reproduced as a greetings card for a nature conservation organization, so the threatening countenance of the mother defending her pup is especially appropriate!

THE BOTTLE-NOSED DOLPHIN

Another much-loved marine animal is this playful member of the whale family who is a star performer at seaquaria, especially in America where it is called the common porpoise. There is a marked difference, however, between a true porpoise and a dolphin. The dolphin, particularly the male, besides being twice as long, has a distinctive, pointed snout and protruding forehead. With its laughing face and agile, streamlined body, it is a popular and decorative subject for artistic mementos.

THE WALRUS

This massive character, popularized by Lewis Carroll, is an imposing member of these sociable, sea creatures and belongs to the same order as the seals. Although it spends much of its time sunbathing on a rocky beach, huddled together with masses of its kind, it also occupies the lonely and distant ice floes where there is at least a temporary respite from the persecution of hunters.

I chose such a background for this picture, which was done entirely with coloured pencils on a heavy, white illustration board with a grained surface ideal for pencil work. You can let the grain come through, or fill the colour in solidly as I have here in the clouds, water and the shadows of the puckered and rough textured skin of the walrus. This is in fact covered with short hairs, the bull's having a reddish tinge while the cow's is more of a subdued brown as in this example, although from a distance, the only noticeable hair is the incredible moustache of long bristles at the sides of the mouth.

The background consists of a wide range of blues plus greys and some violet tones to set off the warm, light browns, creating a cold, misty atmosphere.

The animal is also at home in the icy waters where it goes down, sometimes to great depths, in search of

CÉCILE CURTIS

shellfish and where it can also quite easily fall asleep with all but its nostrils submerged – in a vertical position, inflating airsacs in the throat to support itself.

A Lonely Walrus. *Coloured pencil on textured, white illustration board. 183 × 318mm (7½ × 12½in). These are normally very gregarious creatures, but in times of danger are driven to sheltering on ice floes far out at sea.*

THE BLUE WHALE

This marine mammal, of the same order as dolphins and porpoises, is not only the largest animal in the world today but also amongst any life forms that ever existed. In describing it, all the usual superlatives fail to convey adequately the enormity of its size. A length of $33\frac{1}{2}$ metres (100ft) and weight of 177,000 kilos (135 tons) have been recorded – the equivalent of the weight of 30 elephants or 1,600 men. The width of its tail fins, or flukes, is over 6 metres (20ft).

With a giant of such magnitude, it was a difficult subject to portray. Unlike depicting an elephant, where some familiar point of reference such as an accompanying egret or an acacia tree beside it can give an immediate comprehension of its proportions – the sea has no such points of reference, and in any case, other marine inhabitants would be so small in the composition that they would appear insignificant on this scale.

Being limited to the use of black pen work and solid grey for this particular series of illustrations, I could not express the subtle nuances of slate blue and white tones. I had to devise a technique of black dots, which, in a few places, merge into solid black, having

Blue Whale with young in two-colour line technique.
280 × 483mm (11 × 19in).

first drawn in the outlines and filled in the grey areas. Then I painted the white highlights on the skin and speckled markings scattered over the body. Last came the definition of the form and details of the eyes and mouth as well as the fluted effect in the area of the lower jaw going back behind the flippers. I painted a few large spots on top of this to indicate the barnacles that collect there. The 'baby' is merely a smaller, more simplified replica of its mother.

Few people have ever had the privilege of seeing a live whale in its habitat or are likely to enjoy such an experience in the future, unless they are sufficiently adventurous to join the boatloads of enthusiasts who are becoming part of a new tourist industry.

There are not many clear photographs of these animals, most of which just show a close-up of the flukes as they dive into the water. Other than an unconvincing, mounted version in a natural history museum where its true size cannot be appreciated, the only way to grasp any real impression of it in all its

grandeur is through the medium of films. It was in one of these rare examples that I caught a glimpse of the effect of the sun's rays penetrating the water, which gave me a means of suggesting this environment by employing the same stipple technique used on the whales. As the beams had to be perfectly straight, I used a ruler to guide my pen. I also crossed over the figure of the baby, creating a sense of depth between it and its mother.

The whale's curious method of feeding accounts for the odd, pleated skin below the mouth and flippers. Its diet consists of krill, a small, shrimp-like crustacean, rich in nutriment, which whales gulp down with a great volume of water. They then sieve the water through long fibrous plates of tough hair called 'baleen', which they have in place of teeth, effectively retaining the krill in their mouths. This is made possible by the folds on the lower jaw and throat that expand the mouth in order to accommodate the prodigious intake of water.

These highly intelligent and gentle animals have a complicated system of echo-location, enabling them to make contact with each other throughout their oceanic habitat, which covers the major portion of the earth's surface. Their low, mysterious moaning sounds have been recorded as the haunting 'song of the whale'. Besides being gentle, they are very loyal, a quality cynically exploited by whalers who sometimes harpoon a female first, confident that her mate will stay by her side.

Oppian, a poet from ancient Greece, wrote of a fellow member of this family: 'Diviner than the dolphin is nothing yet created; for indeed they were aforetime men . . .'. It is interesting to speculate on how he would have been inspired by the awesome Blue Whale!

HOOFED ANIMALS

The ungulates, or hoofed animals, are herbivores, feeding exclusively on plants, which they spend a great deal of their lives in consuming. Strangely, they are also the nearest relative to the Blue Whale.

Of the many species of deer, the oddest-looking must surely be the one known as Père David's, which, some say, appears to have been put together by a committee! Certainly, the long tufted tail like a donkey's and neck resembling that of a camel, plus the splayed, cow-like feet, present unexpected combination of features, which prompted the Chinese to call them 'the four unlikes'. Their life-style differs from that of other members of this family as well. They are excellent swimmers and enjoy water, even at great depths, where the younger ones play like seals and feed on the vegetation. Unlike other deer, they shed their unusually long antlers of some 70 to 90cm (28 to 35in) twice a year, the larger of which reach their full size in summer. In common with others, this deer on occasion adds even more height and breadth to his fine status symbols by hooking branches of trees or shrubs onto the ends. As well as being aquatic, they also enjoy a good wallow in mud, flinging it onto their backs with their antlers, presumably for further adornment!

Typically, the stag fights for supremacy of the harem during the rutting season. He uses his teeth, as well as antlers, in the process and, like the Red Deer, also adds some boxing skills into the bargain, standing on his hind legs. With a shoulder height of 115cm (45in), this gives him quite a long reach.

Their colouring is tawny or reddish-brown, sometimes with tinges of grey. The underparts are white as are the large circles around the eyes, which can be seen very clearly in this head-on view done in scraperboard. In both this and the full colour version, the antlers are 'in velvet', their most spectacular stage, when they look even more imposing, particularly in the study on the left where it is more advanced. Black fringes along the top and underneath the neck are just visible in the profile view.

Père David's Deer with visiting bird on white scraperboard used for a greetings card. 330 × 215mm (13 × 8¼in).

Père David's Deer with its saviour in the background. Gouache with sponging technique. 230 × 300mm (9½ × 11¾in).

RESCUE OF A LOST BREED

Their history is certainly outstanding too. Up till 1865 they had been thought to be extinct in their wild, swampy habitat of northern China, so that the intrepid missionary and naturalist, Père Armand David, received quite a pleasant shock when surreptitiously, he caught sight of this strange herd browsing in the grounds of the palace at Peking. It took a great deal of persuasion before he was permitted to ship some specimens to European zoos. At the turn of the century, eighteen scattered survivors were transferred by the then Duke of Bedford to his estate in England, where they flourished; later another group was established at Whipsnade Zoo. Eventually it was possible to present some to other zoos throughout the world including Peking's, in 1956 – half a century after they had lost the last of their *mi-lou* deer.

Thanks to the illicit sighting by that adventurous French missionary, the breed survived and are indeed, Père David's Deer.

In the painting above, I combined them both, showing a shadowy vision of the missionary in the background. I used very thick gouache, applying the violet colour first with a fine-grained sponge to give a matt finish, working into its edges with a lighter tone which also defines the head and the Emperor's palace behind it. With a coarser sponge, I added the blue-green below before painting the deer on top, keeping my mixtures of colour just wet enough for the paint to flow.

THE REINDEER

More familiar than any other species of deer, this appealing animal owes its fame to the task it is pictured as performing every year – pulling Santa's toy-laden sleigh across the sky. It would seem to be a role to which it is well suited, for these amiable beasts have served as draught as well as pack animals since their domestication in the fifth century. They are even entered in friendly racing competitions, pulling a driver and sleigh for 16 kilometres (10 miles) in under half an hour, and their broad hooves serve far better than those of a horse for moving across uneven or icy terrain.

The docile reindeer are known as the cattle of the Arctic amongst the nomadic tribes of Lapps in northern Europe and Asia, who count their wealth by the numbers in their herds. Stags and hinds are also referred to as bulls and cows. Like the Lapps, they are by nature nomads themselves and do not need shelter in the coldest weather. They closely resemble the North American Caribou as well as having some things in common with Père David's Deer – besides their large splaying feet – as they are also strong swimmers but are slightly smaller than either of these. A unique feature is that both sexes have antlers that start to grow when the young are only a month old, whereas other types of deer do not reach this stage until 9 to 15 months.

Inevitably, domestication has meant exploitation, but there are some herds bred from domestic stock in Lapland who now live in a wild or semi-wild state in the Scottish Highlands where the climate is similar to their native habitat. With such a hardy constitution, they often prefer the open hills to the pine forests, even during the most severe snowstorms. It is here that I like to think of them, leading a natural existence in total freedom.

This 'portrait' of a reindeer is really a portion of a painting I did for a Christmas card. As I did not have access to a model at the time, I had to check through my photographic reference material as I wanted it to be as lifelike and detailed as possible. I keep a large file of all kinds of animals photographs, which, in American newspaper parlance, is called a 'morgue'! After studying a number of examples, I extracted some of the best aspects from those which seemed appropriate, adapting them to suit my requirements.

In a conventional version of the Christmas theme, reindeer are usually shown complete with harness, but in this instance, a free and unfettered animal was preferable.

PAINTING PROCEDURE

The colouring and thickness of coat shown here is typical of their winter attire, with a pronounced creamy-white and woolly 'jacket' over neck and shoulders. I darkened the near antler to bring it forward, further emphasizing its length by placing it near the top edge of the composition.

I chose a warm, buff-coloured, *Mi-Tientes* pastel paper, the same shade as that on page 81, as a suitable foundation for the light fur section and also as a contrast to the white snow. The white was applied very thickly in the foreground for a crisp, clean look that also helps to accentuate the sprigs of holly, added with 'artistic licence', as I am not at all sure that it would actually grow in such a terrain, but was necessary for a 'Christmassy' look. For shadows in the snow, I used a fairly strong blue, knowing it would be somewhat neutralized by the colour of the paper which also gives a softer tone to the cold colours of a misty, wintry landscape. The pine forest not only adds to the atmosphere of the setting, but is a convenient foil for the colouring of the reindeer.

Reindeer. Gouache on pastel paper. 254 × 353mm
(10 × 13½in).

CÉCILE
CURTIS

THE WILDEBEEST AND THE ZEBRA

The wildebeest, or gnu as it is also known, is sometimes called ugly, but could be better described as is the wart hog, *un joli laid* – 'a lovely ugly one', with its large head crowned by formidable horns and its flowing white beard.

The thundering hooves of this powerful antelope with bovine characteristics, cover the vast plains of south eastern Africa in search of their staple diet of fresh green grass and are usually accompanied by herds of zebra whom they outnumber two to one. Both species enjoy a peaceful co-existence, as the zebra eat only the older grasses, so there is no rivalry for food.

Left, Wildebeest, *225mm (8¾in) square;*
Right, Waterhole *178 × 229mm (7 × 9in),*
both scraperboard; below, *pencil*
drawing for scraperboard illustration of zebra.

Appearances to the contrary, the zebra is taller and heavier than its horned companion. Its similarity to a horse is striking when in silhouette, but this striped version is considerably less approachable!

These pictures are from one of my books which was illustrated throughout in scraperboard. On the portrait of the wildebeest, the horns, top part of the mane, and frontal plane of the face were scraped out from black. The vignette, a detail from a larger composition, shows the two species in typical, friendly proximity.

CÉCILE
CURTIS

THE GIRAFFE

The first time you see one of these close up, your reaction is admiration mixed with a certain sense of disbelief. They *are* the tallest animal in the world with a height of as much as 7 metres 75cm (18 feet) and all movements seem to be in slow motion. Even when running across the plains at full speed with their characteristic, top-heavy, rocking-horse gait, the illusion still persists.

Their favourite food is the prickly acacia's branches, which they clasp with a long extensile tongue. Putting my hand up to stroke a lowered head, I discovered it is also very rough.

Everything about the giraffe seems extraordinary – from the unique reticulated markings, pale buff on a

The portrait opposite was published as a fine arts print, 230 × 225mm (9 × 8¾) and the illustration above, reproduced here in half the size of the original, both in scraperboard technique, appeared in one of my books with an African locale.

rich brown background, to the incredibly long limbs and neck. The head, with its skin-covered horns plus smaller knobs, front and back, and large, fringed eyes, certainly does possess a peculiar charm. Lowering this to ground level for a drink is quite a feat; it does this by spreading its front legs very wide, or dropping down onto the knees. With thirst quenched, the whole awkward process has to be slowly reversed.

With these outstanding features, the animal is a wonderful subject for artists, even within the

limitation of black and white. These two examples are again scraperboard technique where the use of a multiple tool on the strongly-patterned coat makes it easier to express the form. The head-on view, looking up at the face, gives a sense of height, which, in a photograph, would have seemed very distorted. The profile opposite shows the remarkable proportions of the comparatively short body and sloping back merging into the neck, plus the long graceful tail.

WORKING AT ZOOS

I am often asked how my interest in portraying animals began. The answer is that it was always there, but I did not become fully aware of it until I went to art school and realized that there was something missing. My days started with life classes followed by the various aspects of illustration and composition, and in the evenings I attended extra classes in portraiture and still life. Then I discovered it

was possible to get a sketching permit to use before the nearby zoo in Central Park was open to the public. The first morning I turned up eagerly at 7.30 and was escorted to the Lion House which contained all the large felines.

As the heavy doors shut behind me, I found myself alone and, instantly, all the four-legged residents

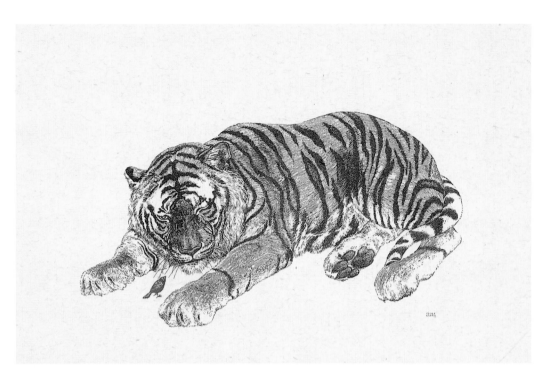

Young Tiger and Friend.
Scraperboard, greatly reduced from 318 × 565mm (12½ × 22¼in).

started to roar in a deafening chorus. I followed my immediate instinct and made for the exit, but no-one had bothered to tell me I would be locked in! It was a salutary lesson in concentration.

I sometimes recall that noisy solitude with nostalgia, as it was infinitely preferable to the jostling crowds at other zoos. My feelings about such venues for working are mixed. The distressing sight of animals in small, bare cages is utterly depressing as well as inexcusable. Nowadays, however, they are usually given sufficient space, both outdoors and inside, and have moats instead of bars, toys and equipment for play and exercise and most importantly, companions. In future, these should only be the progeny of animals who were also born in captivity, and the capture of wild specimens will cease.

Besides instilling in visitors a sympathy and interest in wild animals, zoos are the obvious place where one can learn to draw them. As they frequently sleep, or disappear to indoor quarters, just when you feel you are getting something down on paper, it is easier if there is more than one of your subject in view so that you can at least switch to another, if need be.

Never work from photographs until you have mastered the art of sketching and learned something about an animal, face to face, where there are so many impressions to be gained. Sometimes photographic perspectives can be misleading and most do not capture those unusual details that make a study individual and interesting. There will of course

be many occasions when you have no choice, but with a good foundation derived from working with live models, you will be better equipped to interpret them correctly.

CARNIVORES – THE BIG CATS

First amongst this order must surely be the lion, followed by the tiger, cheetah, leopard, puma, and on down – a fairly large group. Although known as the 'King of the beasts', the lion is far from being the most enterprising, sleeping for 23 hours a day! Aside from his personal habits, he is undoubtedly handsome.

I was once commissioned to do a painting of one for a large office and invited the client to select the animal he preferred at the London Zoo. Afterwards, I obtained permission to set up my easel just inside the railing in front of the cage to avoid the throngs of visitors. My problems had just begun, as he was rarely awake. The solution was to return with a generous quantity of meat which my husband patiently doled out to him at appropriate intervals. I should add that this was only possible after obtaining prior consent – feeding zoo animals is normally strictly forbidden and quite rightly so.

The drawing of the tiger on which I based the above scraperboard study was a different proposition, as I wanted a sleepy animal, just waking up to find an unexpected visitor. This design was one of a series of greetings cards with all the animals accompanied by a little red bird.

Although the problems involved in drawing wild animals from life are usually numerous, I have occasionally been offered an opportunity not to be missed. One of these was provided by my sister who casually mentioned that she knew the author Dan Mannix and his wife Julie, who lived in a rambling old farmhouse on an estate outside the suburbs of Philadelphia. I was aware of the fact that they kept a cheetah and Bald Eagle in their home and asked Marguerite if she could arrange for me to sketch them.

It was an exciting prospect to have obtained intimate access to two such rare species, but as I entered the long driveway on the appointed day, I was totally unprepared for my reception. The moment I left my car, I heard a loud beating of wings and looking up, to my horror, saw an incredibly broad wing span bearing down on me. The huge bird

Cat Nap. *A tame cheetah drawn from life using an* HB *and* 2B *pencil.* 210 × 335mm (8¹⁄₂ × 13¹⁄₄in). *It is the only member of the cat family with semi-retractile claws. In this view, its dog-like paws are clearly evident. Notice how the spots, although irregular in shape and varying greatly in size, still express the form of the animal which is sketched here without much use of light and shade. The relaxed pose certainly belies its reputation as the world's fastest quadruped! This remarkable pet was the proud possession of author Dan Mannix. As well as being a rare species, it could fit into the category of either 'pets' or 'domestic animals', although it is not recommended for the average household.*

Being somewhat unnerved by this initial encounter, I made my way rather shakily toward the house. Dan answered the door and led me to a large living room where the peaceful scene was reassuring, if a trifle unusual. A small boy lay on the floor playing with a toy aeroplane while his mother was curled upon the settee writing a list. The noise of a vacuum cleaner drowned out any extensive conversation. It was being wielded by their Jamaican housekeeper with total lack of concern as the most exotic of felines threaded his way daintily amongst its coils. After shouted introductions, I gathered that the family would soon be off on safari in Africa again and that just now they were all going out shopping for this event, so I would have Rahni and the house to myself. I was told that my prospective model would most likely want to wander around the various rooms for a while. 'If you can't find him, it means that he'll almost certainly end up on our bed,' they said.

With this cryptic advice, they departed, leaving me to stalk this beautiful creature through extensive series of rooms. Our journey included a trip to a bathroom where, finding the lid of the toilet was closed, the cheetah clawed it, hissing loudly. I was, understandably, a bit reluctant to approach him too closely at this early stage in our acquaintance, but he was totally determined. As the owner of a German Shepherd Dog with the same lamentable habit, I knew only too well what he wanted. Obviously he had been allowed to indulge it, so there would be no danger from chemicals. At last I very gingerly reached over to lift the lid so that he could have his drink.

Just as predicted, he did end up on the double bed with its beautiful embroidered cover, and obligingly fell asleep. Half an hour passed in blissful tranquillity as I sketched eagerly, accompanied only be very loud purring like an outboard motor. All went well until suddenly it stopped, and Rahni quickly raised his head from the pillow, his enormous golden eyes staring at me in amazement. I froze, sketchbook balanced

stopped just a short distance from my feet and only then did I realize that it was tethered by a long chain. This was my first meeting with Aguila, the Bald Eagle. Feeling rather foolish, I waited until we had both calmed down a bit and then stood back to admire her splendid brown and white plumage, intense yellow eyes and formidable beak, but decided to postpone any more prolonged study until after I had been formally introduced.

carefully and pencil poised. It seemed an eternity before those few seconds passed and he dropped his head back onto the pillow once more. An hour later we were old friends and I was honoured with a lick on the hand by a sandpaper tongue.

Some months afterwards I was chatting with two keepers at the Philadelphia Zoo and asked them which breed of the big cats in their charge made them the most wary. They both agreed without hesitation, the cheetahs. I felt rather proud to be able to count Rahni as one of my friends.

It was some years before I met another cheetah. This one was called 'Rabiu', who was formerly a regimental mascot in Kenya, just arrived at London Zoo. I asked if I could join him in his cage as I thought he might appreciate some human affection, which indeed he did, giving out the characteristic loud purring and sandpaper licks I had come to know. I can only hope that he eventually found another home as agreeable as his former one.

Family of cheetahs. Orange, black and grey pencils on heavy, slightly textured board in the size of the original. The cubs have found their favourite plaything, their mother's tail! Notice how the use of grey softens the shadows in the white fur and distant landscape.

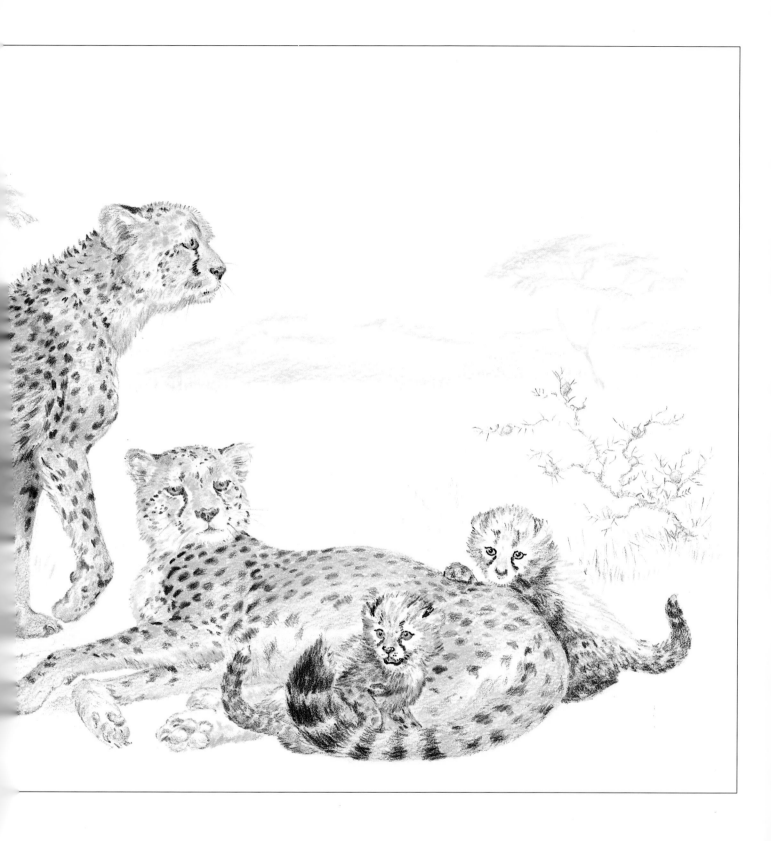

THE GIANT PANDA

Probably the best loved of all animals, this cuddly, black and white 'teddy-bear' is seldom seen either in the wild or in captivity, but I was privileged to be able to sketch and study three of them – a single female and a young pair at London Zoo. Called 'big bear cat' in Chinese, the likeness to the former is far more obvious than to the latter.

Although their main diet is the suitably decorative bamboo, they are classed as carnivores, enjoying fish, which they catch in a typically bear-like manner with a powerful swipe of a broad forepaw, as well as occasional birds, snakes or insects.

The first thing you notice about them is that they are not purely black and white but have many subtle variations of browns and yellows in these two areas. With such a popular subject it is something of a challenge to show it in a less familiar aspect, of which

Ground-level view of two panda cubs. Preliminary pencil drawing for scraperboard illustration. $155 \times 305mm$ ($6\frac{1}{8} \times 12\frac{1}{2}in$).

I was particularly aware when preparing a book about it. The above drawing was the result of seeing one of the pair peeking around a large pot of bamboo plants. I decided on this low-level angle which mainly features their two round faces.

The pencil study opposite shows the strongly maternal bond between a mother and her cub. Here their expressions are the all-important factor, and like the cheetahs on the preceding pages, could easily be expressed with just black, grey and one colour. Often, the subject matter determines the media.

Giant Panda mother and cub. Black, grey and green pencils on smooth, ʜᴘ surface illustration board. 394 × 263mm (15½in × 10½in).

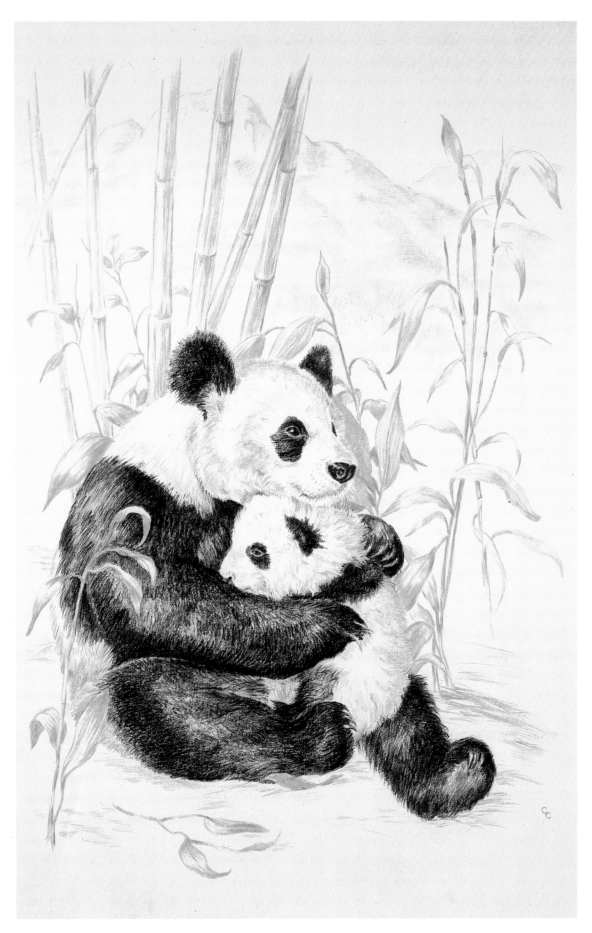

BIRDS

AT THE SEASHORE

This is an excellent place in which to study a variety of creatures, especially birds. The most common of all is the gull, particularly the Herring Gull, once associated exclusively with the seaside, but now found far inland as well, in both town and countryside where its diet has become extremely varied.

The Crested Caspian Tern is the largest of more than 30 species and is related to the gull. Distinguished by a forked tail and tapering wings, it is sometimes called a Sea Swallow. In flight, it flutters rather like a butterfly, with the beak pointing downward.

The oystercatcher is a large wading bird, usually black on top and white below with powerful red legs and a long red bill with which it retrieves and opens any available shellfish as well as crabs and shrimps to be found lurking in the sand. It can also be seen in estuaries where pickings are plentiful.

Here too is that familiar riverside inhabitant, the graceful Grey Heron, which is marvellous to study as it stands perfectly still, one leg raised, in search of an aquatic meal, which it catches with a rapier-like thrust of its long, sharp beak.

Above: *Herring Gull.* Below: *Crested Caspian Tern and young with oystercatcher. Inset: sandhopper. Opposite, above: At The Estuary; oystercatcher, heron, shelduck with Netted Dogwhelk. Inset: cuttlefish. Below, left: gannet and, right: shag. All done in gouache on illustration board and reproduced in the same size as the originals.*

The bright-plumed shelduck, largest of all the ducks, has characteristics of a goose in its rather slow flight, also inhabiting estuaries as well as the coastline and nesting near the sea.

Along the coast, the shrill cries of the gannet can be heard at a great distance as it 'dive-bombs' from high cliffs into the ocean, catching a fish on the way back up to the surface. These birds are fierce fighters when defending territory and peck furiously at their mates during courtship. They are about the size of a

goose and can cover vast areas of the sea with amazing speed. The expression 'gannet-like' originates from their habit of building huge, complicated nests consisting of practically anything they can find, such as tin-cans, fish nets, jewellery and even false teeth – the origin of which is difficult to imagine – all packed together with grass, earth and seaweed.

The shag, or Green Cormorant, varies from the common version of the latter species in that it does not have white patches on the head, but a crest instead during the breeding season. Like the gannet, it is aquatic, diving into the sea to catch fish that it swallows, head first.

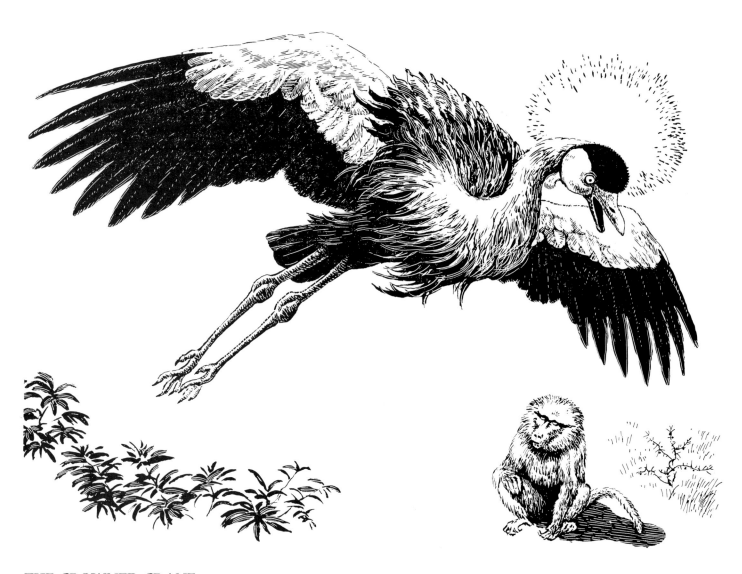

THE CROWNED CRANE

Of all the 14 species of cranes, this native of south
east Africa must surely be the most impressive with its
magnificent, bouffant headdress of soft feathers
forming a russet halo and a bright red wattle plus
black and white plumage touched with gold on the
wings. The most outstanding feature of these stately,
elegant birds, nearly the height of a man, is their
delightful series of dance routines, which culminate in
a swift flight into the air, descending gently in
graceful and slow-motion, balletic movements. It is a
characteristic activity of all cranes enjoyed by groups
as well as courting pairs, and with a wing span of as
much as 2.36m (7½ft) it is certainly spectacular. Their
life span is also long, a half century or more, but most
races are becoming increasingly rare, though
fortunately, many countries are making strenuous
efforts to preserve them.

*Above and below: the graceful Crowned Crane in flight and
close-up using scraperboard combined with pen and ink
technique, reproduced in one half size of originals. They appeared
in one of my books with an east African setting.*

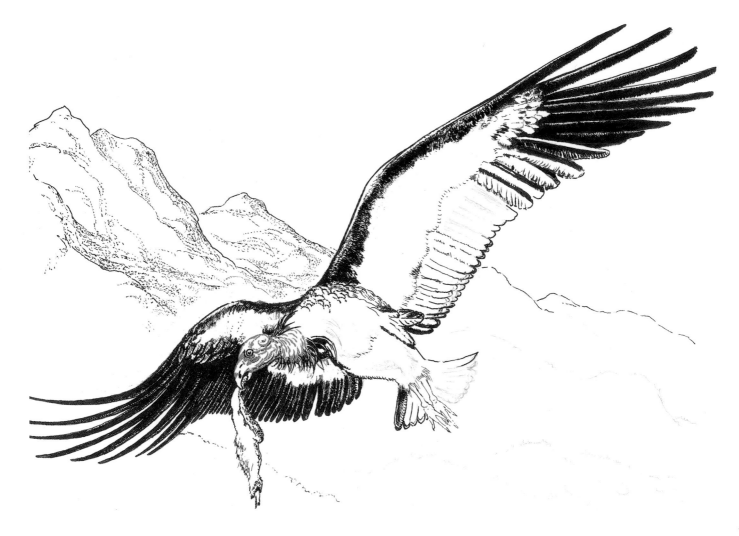

THE CALIFORNIA CONDOR

With an even greater wingspan of 2.75m (10ft), this mighty bird soars over the highest mountains with the ease of a glider and can ascend to such an altitude that it disappears from view, from where its phenominal eyesight is still capable of spotting carrion, its principal diet, even from this lofty vantage point. It also enables the bird to observe another of its kind, suddenly dropping down to retrieve a meal, thus with the typical behaviour of scavengers, several may gather over a find. It is one of only two species of condor, its Andean cousin being slightly larger with a white ruff around the neck instead of blackish plumes.

This unfinished study gives a fairly graphic idea of the various divisions of wing feathers, as does the one opposite. The shorter ones on the leading edge of the wing are called coverts, with nine of the longest flight feathers, called primaries, at the tip of the trailing edge. As the black areas here have not yet been entirely filled in, their differences are more obvious. It is not usually appropriate to show them completely

Partially completed drawing of California Condor in pen and ink with some red opaque watercolour. 222 × 322mm ($8\frac{3}{4} \times 12\frac{5}{8}$in). The area shown is only a part of the entire composition.

divided from one another, however, as movement tends to make the sections merge into each other, but as can be seen from both examples, the basic formation is the same.

The majestic condor mates for life, which like the crane's, may last for a good fifty years, but the survival of this rare creature in its rarified atmosphere is critical, as are many of my wildlife subjects, giving this work a particularly poignant urgency.

THE JAPANESE CRESTED IBIS

As rare as the California Condor, with just a precious few left on one or two islands of the coast of Japan, is this fragile cousin of herons and flamingos.

Photographic references of all such endangered species are very difficult to find. Those that I did obtain were mainly of captive specimens from whom, it is fervently hoped, a breeding stock may one day be transferred to their natural habitat of dense pine forests.

The most striking feature is the scarlet mask with legs to match, contrasting with white plumage which in the young birds, is an inconspicuous grey. I did this gouache study of them using a sponging technique with a smooth, matt finish as well as open applications of colour. The painting on top is put over this very thickly, with the adult bird's wing tip just outside the free-form background, which is very simplified and somewhat stylized to give the birds more prominence.

The pen and ink drawing on the left shows more detail in the feathers. Like the parrot's, two of its four toes can point backwards for a firm grip on branches, and its resemblance to the familiar heron is quite marked.

CÉCILE
CURTIS

Above: *mealtime for a Japanese Crested Ibis. Illustration for a children's book. Gouache on* HP *fashion plate board, same size as original. Left: pen and ink version 255 × 210mm (10 × 8in).*

Sketches opposite: above left – *Philippine Monkey-eating Eagle;* right – *Chilean and Australian Wedge-Tailed Eagles.* Below: *swans feeding. Two-thirds size of original pencil drawings.*

Room for One More? *Gouache on mounted, light-blue Ingrés pastel paper. 228 × 305mm (9 × 12in).*

I sketched the birds of prey and feeding swans opposite very rapidly from life, using sepia and burnt umber pencils. Eagles always make a dramatic subject with their fiercely alert eyes and powerful talons, instilling a sense of fear in some creatures and an awesome respect in man.

SWANS

Perhaps the most romantic of all birds, the swan is steeped in an aura of magic and mythology as well as symbolizing grace and beauty. Choreographers endeavour to emulate its movements for dancers; musicians use it as a theme for melodic and mysterious compositions; and artists are constantly inspired to portray it in different moods and techniques.

I painted the swan family above using a pale blue background for the predominantly light areas of water and built up the darker tones behind the largest figure to make the white feathers more pronounced. A slight ripple in the still surface of the river enabled me to break up this swan's reflection and avoid having it extend too far down in the composition. The fine, grainy texture of Ingres paper is sufficient to vary these tones and still allow a smooth application of white paint. I used pink water-lilies for a variation in colouring and the same soft brown as on the young cygnets in the pen's neck feathers.

A PAINTING IN FOUR STAGES

In the previous demonstration on pages 68 to 71, of progressive stages of a painting in gouache, the subject was a vignette on a white background. For this more complicated composition, I chose tinted *Mi-Tientes* pastel paper in a warm grey with a slight, greenish cast for a group of swans in a landscape.

As lighting played a prominent part in the effectiveness of the picture, I made a very small pen and ink sketch first to plan the distribution of light

Pen and ink 'thumbnail' sketch of composition, (shown actual size). Below: preliminary colour sketch 191 × 255mm (7½ × 10in) using coloured lead, pastel and chinagraph pencils on tinted paper. Line on left indicates where the picture has been extended. Opposite: drawing enlarged onto textured watercolour paper 286 × 380mm (11¼ × 15in); foreground area has been partially filled in with watercolour and coloured pencils, some gouache on house, chinagraph on other swans.

and dark areas without the distraction of colour. The second stage was a preliminary colour sketch two-thirds the size of the final work; I incorporated all the elements in the picture but extended it to the left and added another swan and the tree. The line of the addition is just visible in the reproduction. For this I

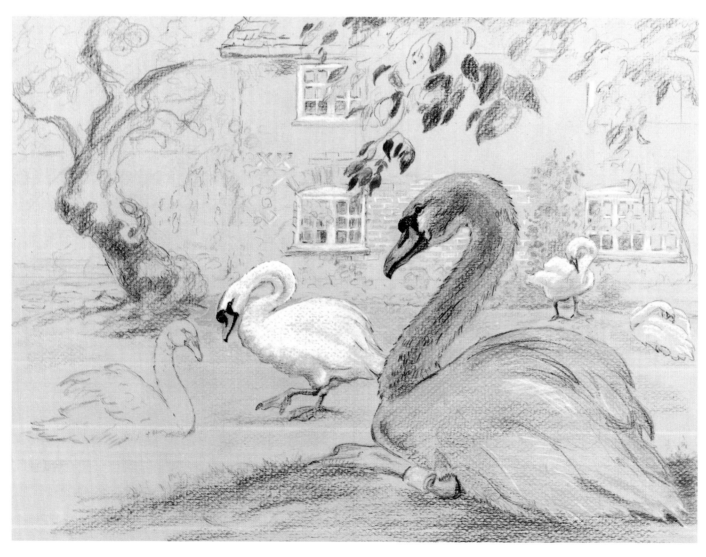

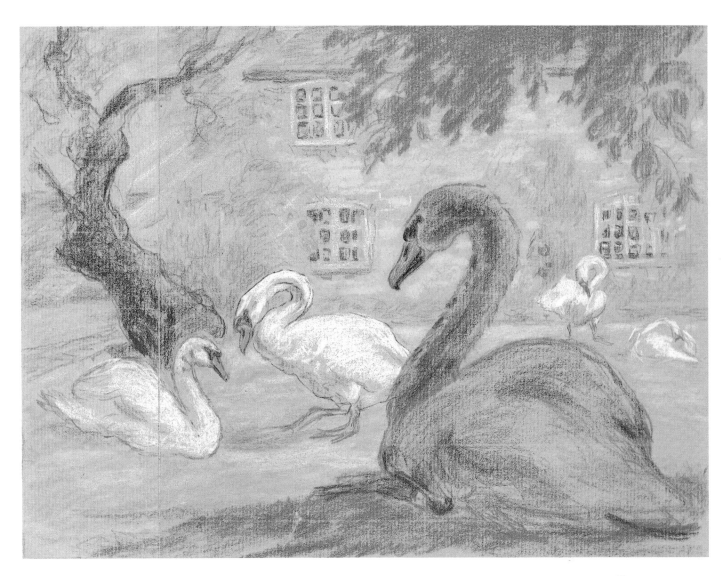

used *Ingrés* paper in a similar tint but with a finer-grained texture. Colour was expressed very rapidly, mainly with pastel pencils without much detail, merely to obtain a quick impression. This procedure, though seemingly lengthy, can really save you a lot of trouble when executing the final, full-sized version, as any problems can easily be corrected at the earlier, smaller stage. The positions of the roots of the tree-trunk and left-hand swan were adjusted slightly, and windows plus other details of the house indicated more exactly as can be seen in the enlarged drawing shown above. I then started shading the darkest areas using the sides of coloured pencil points on the foreground swan, tree trunk and leaves above, painting in a few of these quite accurately to give them their true value in comparison with the head of the swan beneath them. Next came the very exacting work of painting in the warm colours of the weathered brick behind it, conveying texture and much variation in tone and at the same time,

ensuring that it enhanced rather than detracted from the head. The colouring and placement of the flowers had to be done with care as well in order to avoid conflict with all those warm tones, which could easily have occurred.

In the final stages of painting, I also varied the shades of green on the overhead foliage, indicating the apple tree impressionistically. Here, as well as on the swans and grass, I exploited the rough, canvas-like texture of the paper, which provided me with the opportunity to introduce a different technique.

The swan's white feathers in the middle distance were accentuated with paint to make them stand out more than the preening pair at the back, and the foreground was washed over with subtle shades of green and blue.

THE SANCTUARY

I have always had a particular affection for swans and have drawn and painted them many times over. What I really wanted, however, was a more unusual setting than their normal habitat. I also longed for the opportunity to observe them rather more closely than is normally possible, but in relative safety as well.

Hearing that there were swan rescue organizations, I was determined to find one that was within a reasonable distance. I had almost given up when, after several false leads, a telephone call came from a member of their rescue team who offered to take me to a sanctuary at Outwood in the heart of the Surrey countryside.

As Kay Webb and I drove through narrow lanes under a threatening grey sky, I felt a certain sense of misgiving, aware that some of these birds had suffered appalling injuries and did not know what to expect. Eventually, we arrived at a gate which was opened by my charming hostess, Marjorie Unwin. At that moment, the sun burst forth and I saw her radiant smile and beyond, an enchanting cottage which, I later learned, had historical Tudor connections and is part of a National Trust property. On the lawn surrounded by flowers was a circle of happily-recuperating swans, nursed lovingly back to health by the single-handed efforts of Marjorie.

After prior consultation with her and a generous hand-out of bread, I sat and sketched very near to that exclusive circle, of which each one was known to her by name. There were other birds as well to enjoy the different, especially constructed pools, and Canada Geese plus a pet duck who was not averse to being a 'house duck' from time to time, mingled quite amicably with the rather more reserved swan residents. There was so much in a relatively small area to see and sketch, but I had to concentrate my attention on the object of my visit.

This composition was inspired by that scene which awaited me when at last, after months of fruitless enquiries, I finally found what I had been searching for.

Swan Sanctuary. *Painting completed, based on the rough colour sketch, with position of bird on left slightly altered. Note that the area behind the head of the one in the foreground is clear of any fussy detail, the warm colouring of the weathered bricks complementing its cool, dark greys. Chinagraph pencil on the sunlit swans and tree trunk gives the impression of oils on canvas, utilizing mainly the grey of the paper itself for shaded parts of the plumage.*

CÉCILE CURTIS

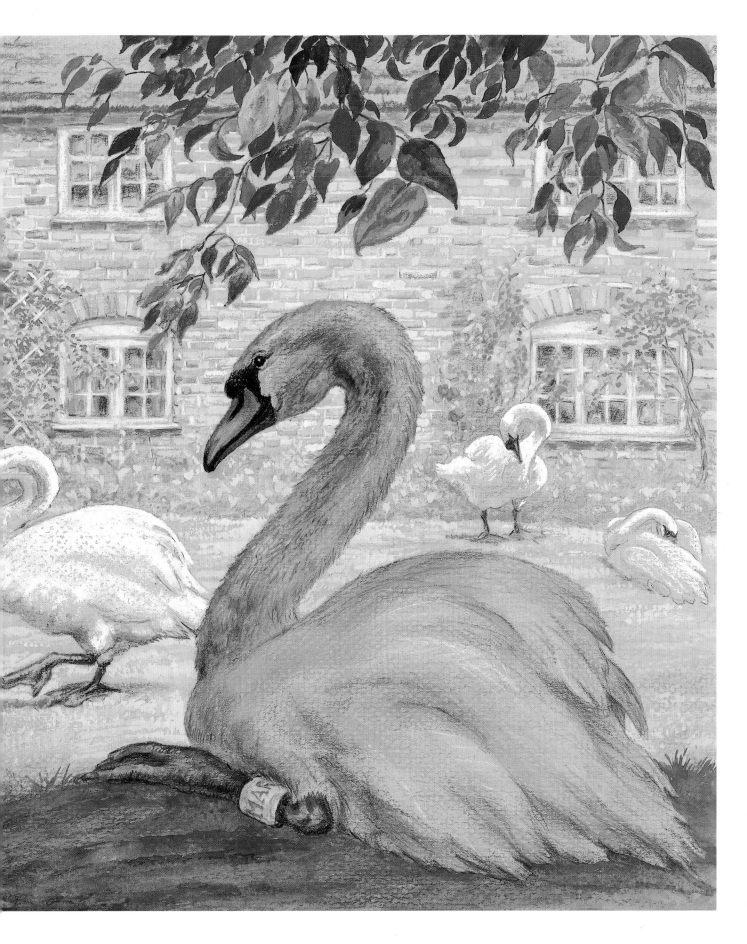

129

PROTECTIVE COLORATION

Perhaps the best definition of this phenomenon is 'camouflage', the art of disguising a shape, outline, object or creature to look like something else or disappear altogether. Man first made a serious science of this practice during the First World War, but many animals have acquired it naturally through evolution. Think of how many species are light underneath and dark on top – the list is very long. These are mainly animals living on open plains, or other predominantly sunny locations, but it also applies to fish and birds, as well as some nocturnal creatures for whom the system would work equally effectively in moonlight.

THE CHANGING COAT OF A CHEETAH

There are several examples within these pages which fulfil the first condition. The cheetah, as shown in a family group, is one of them. The top of this 'hunting leopard' is a tawny orange where light strikes the figure, and white underneath where the shadows fall – thus presenting a flattened image to either predator or prey. Their young have an entirely different type of longer, lighter fur down their backs to the base of the tails rather like an elongated shawl which must help to conceal them in long, straw-coloured grass. As they grow above this level, it gradually disappears and the adult's spots become visible.

PATTERNS AND HABITAT

Spots, though not so obvious a device, are also very efficacious. The many species that possess distinct patterns do so for a reason, such as to blend into surrounding vegetation, dappled sun or moonlight where the figure can be difficult to see against a similar patterning in its habitat. Stripes also provide good disguises amongst long grasses, imitating the shadows cast by them.

AQUATIC DECEPTION

The seal family has a system of blotches in the fur's colouring that match the patterns of light and shade under the sea. These are also paler underneath so that when viewed from below, an animal seen against the sky above, will merge more into its surroundings and, when viewed from above, will present a less conspicuous form in the darker element of murkier waters. The same theory applies to other sea creatures, from the smallest fish to the mighty whale.

THE MYSTERIOUS OKAPI

In the damp Ituri rain forests of the Congo, lives a strange cousin of the giraffe. It also has the distinction of being the last large mammal to be discovered in Africa. As recently as the turn of the century, Sir Harry Johnston, whose name it bears (*Okapia johnstoni*), was privileged to announce his exciting find to the outside world.

The mother and her baby opposite, show the curious striped bands on legs and rump in their velvety, red-brown coat, which becomes lighter in older animals. The female is larger than the male in this species, but does not possess his giraffe-like horns. The unusual marking is in keeping with their inaccessible habitat of riverside clearings surrounded by dense trees festooned with parasitic plants that grow on them and cast the same pattern of shadows in the occasional shafts of light.

This type of habitat required a limited range of muted colours combined with the rich tones on the fur in the sun, whose rays were done with an erasing shield. I chose this angle of the mother's figure as seen from her baby's eyes.

To create an interesting and effective composition of wildlife in its natural surroundings the more you can find out about your subject, the better are your chances of success. The dark background plus exotic vegetation here add greatly to the presentation of the animals themselves, but this was only possible to depict after thorough research.

Mutual Admiration. *Okapi and baby, coloured pencil on heavy illustration board. 410 × 315mm (16⅛ × 12⅜in).*

FIND THE TAPIR

The protective coloration of most animals is, therefore, an indication of their habitats. Perhaps the most puzzling of these must be that of the Malayan Tapir. Its South American counterparts are a dark, reddish brown, but this eastern race is basically black, or very dark brown with a broad white area around its body, which would seem to make it very conspicuous indeed. These nocturnal feeders, about the size of a donkey, spend the day in dark forests, coming out at night to browse on land and aquatic plants. It is only when you discover that one of the most plentiful forms of vegetation in its habitat is the huge, broad-leaved *aracaea*, which cast large patches of shadow in moonlit areas like the tapir's marking, that the coloration begins to make sense.

Above: pencil studies of top and lower surfaces of aracaea.

The photograph of the sculpture opposite demonstrates this function, showing the effect of one of these on the animal's back. Taken under a strong light, it also suggests the beneficial effect that bright moonlight might have on the baby tapir who is barely discernible in the shadows. The young of all the tapir races have this odd series of horizontal stripes and spots and, like the cheetah cubs, they eventually change to their parents' colouring. The distribution of both markings is indicated lightly in the sketch below the photograph, and the one showing the leaves can be compared with the sculptured versions of them.

Above: *figures photographed in 'simulated' moonlight.*

Below: *rough sketch for sculpture of Malayan Tapir and young.*

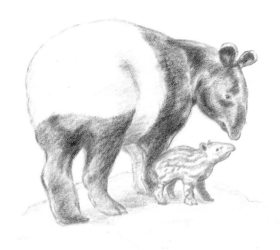

SYMBIOSIS

Rhino and Cattle Egrets. *Pen and ink on illustration board. 190 × 305mm (7½ × 12in). Opposite: Pair of Giant Sable Antelopes and oxpecker. Two-colour pencil on heavy board. 406 × 305mm (16½ × 12in).*

BENEFICIAL BIRDS

Rhinoceros are often seen with cattle egrets perched on their backs or confidently strutting around their feet. The contrast between this gigantic, prehistoric creature and the dainty and graceful white bird presents a charming picture, but also has practical motivations. The birds consume numerous insects that plague the rhinos despite their tough skins, and in turn, those huge feet disturb others lurking in the grass, providing yet more easy meals for their feathered companions.

Another bird that is most welcome by its hosts is the oxpecker or tick bird, as it is sometimes known. Its whole life revolves around the herds of African hoofed mammals, one of which may carry a dozen or more clinging to its head and body with long, curved claws that permit it to remain attached to the sides or underneath an animal and even drink at the same pool whilst clinging to its cheek!

Opposite, the rare, Giant Sable Antelope of Angola in west Africa has the yellow-billed variety serving its willing mount, who also relies on warning calls from the bird in times of approaching danger. I included one of these in the sculpture of that animal as well. There is another, almost identical breed of oxpecker that has a red bill and makes itself useful on the eastern side of the continent.

CÉCILE
CURTIS

THE HOSPITABLE BADGER

There are instances when an animal may co-operate with another of a different species without receiving any reciprocal response. One such case is the curious housing arrangement between foxes and badgers. The latter is an excellent homemaker in its elaborate network of tunnels and inner chambers called setts. Its bedding is constantly changed or put out to be aired by this fastidious housekeeper, and contains a fine array of plants gathered from its sylvan habitat plus adjacent pasture and hedgerows. The path to an entrance may be strewn with bracken, bluebells and other flowers dropped along the way. Setts can cover an underground area as large as two tennis courts and contain as many as 50 entrances from which, at a prudent distance, special latrines are constructed.

Despite these precautionary measures, badgers will permit a family of foxes to move into their tidy

Badger's Spring. Watercolour/gouache. 215 × 350mm (8½ × 12in).

quarters with no evident advantage to themselves and will even tolerate being teased by them! Rabbits sometimes move in as well, which would appear to be a very unsatisfactory state of affairs, especially as the badger is a good deal larger and certainly well equipped to defend its woodland home from such intruders. This combination does not seem so incongruous, however, as that of the tuatara from New Zealand – called the three-eyed lizard because of a vestigial eye on top of its head – who shares its burrow with shearwater petrels. This alliance is all the more perplexing in view of the fact that the lizard is known to make an occasional meal of a petrel's egg or chick, and even the bird itself!

As well as being monogamous, the fox and badger

Fox Chase. *Watercolour on white illustration board, designed for a Christmas card. The holly was added as a concession to the festive season. 215 × 350mm (8½ × 12in).*

are model parents, with the male fox helping to feed and care for the young cubs. When the fox and vixen go out hunting, the cubs are left in the charge of an 'auntie'.

The offspring of both species enjoy increasingly boisterous play activities, with mock battles to prepare them for their future role as predators, which also help to establish a pecking order in the group. Play can often be benign as well, and many larger, more powerful animals will 'handicap' themselves when playing with a different, more vulnerable species. Happily, this pastime is not limited to the young, and adult members of a group, especially the badgers, have often been observed in a jolly 'free-for-all'.

The watercolour above was designed for a Christmas card, and the badger family was part of a series featuring different species with their offspring to be used for a variety of purposes including general greetings cards. As the badger cubs are cautiously introduced to the outside world in the spring, the woodland bluebell was an appropriate flower to feature in this composition. The colouring in the landscapes of both pictures is slightly exaggerated as the cards needed to be rather bright and eye-catching. This one was done mainly using a watercolour technique with some thicker, opaque paint in the foreground and a black pencil used sparingly to express the characteristically rough texture of the mother's fur.

Strange Bedfellows. *Brush and broad-nibbed pens with coloured pencils on Mi-Tientes paper. The tuatara is the only surviving member of a very ancient group of lizards called beak-heads which predate even the dinosaurs, and possesses remnants of a third eye at the back of the skull. The sooty shearwater petrel resembles an albatross in flight. This curious pair maintain a tenuous relationship in their shared burrow in the rich humus under a canopy of low-hanging trees, as the bird is sometimes prey of the lizard! $216 \times 180mm$ ($8\frac{1}{2} \times 7\frac{1}{8}$in).*

ANATOMY AND
ANIMAL EXPRESSIONS

Pencil drawing of dog's head showing direction of fur's growth with minimal shading to give greater emphasis. 136 × 190mm (5¾ × 7½in).

ANATOMY

THE HEAD

On the preceding page is a sable-toothed tiger's skull and reconstruction of the animal in red. The domestic cat's skull above it shows their comparative sizes and the relationship between bone structure and the form over it. The prehistoric feline was done at the British Museum of Natural History when that section of the museum was closed to the public for renovations. I was fortunate in obtaining permission to work there, and was able to make a detailed study, unhampered by the usual crowds of visitors.

After drawing it carefully in pencil, I used a technical pen to fill in the shading afterwards, and the visualization was painted on top with gouache, including a missing tooth in the lower jaw.

THE COVERING OF FUR

The above pencil study is designed to demonstrate the variety of ways in which the fur grows on a dog's head. I used my black Great Dane as a model without showing his colouring as the hairs would not be as distinguishable if very dark, and slightly exaggerated their length.

There are five places where these abrupt changes create ridges. Below the ear on the neck are two circular ones formed by fur growing in four different directions at the centre of which there is a tiny, round bare spot which is only visible on short-haired animals under close examination. I have made a small circle here to mark it more exactly. Two other places are located around the ear, one in front which forms a semi-circle, and the other at the top where the hairs tend to stand up slightly. Others can be seen beneath the eye as the hair grows downward from the top of the foreface, and on the apex of the brow where there

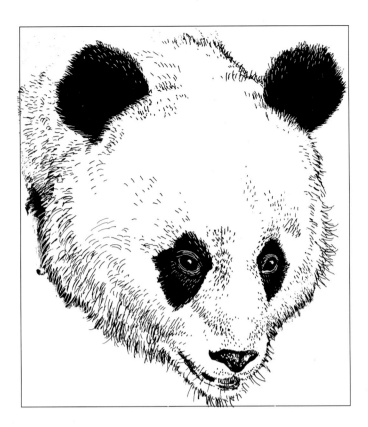

Above: *Giant Panda. The inked lines between its eyes show the demarcation in the white hairs.* Right: *Scraperboard study of Red Squirrel, one third the size of the original. In this medium its long hairs can be clearly defined.*

is a 'nerve boss' from which 'feelers' or whiskers, grow. There are two more of these on the side of the jawline below the cheek and one directly underneath. I made them a little larger and more prominent for easier identification. The 'whisker bed' on the muzzle also contains many nerve bosses.

These principles apply to all canines, even the long-haired Old English Sheepdog, though they are more obvious in the short-haired varieties.

Other typical features are the row of serrations on the lower lip, called 'flews', and the folds of skin, or 'dewlaps' at the front of the neck.

The fur of the 'big-bear-cat' below shares a characteristic with both those animals in that the hair changes direction between its eyes. No other species exhibit this unique feature, which inclined zoologists, after much deliberation, to place this puzzling animal in the same classification as the bears – proving the importance of such seemingly insignificant traits.

The coat of fine and luxuriant hair on the red squirrel above is much more straight forward, where the lines follow the form underneath, and is readily interpreted in scraperboard. This is one of the

examples in my book on the medium to convey various ways that can be used in expressing textures.

As well as adding to its anatomical accuracy, an analytical observation of these subtle variations that occur in different animals gives your picture a lifelike quality, whether in colour or black and white.

Koala with 'Joey' on Board. *Black, grey and green pencil on heavy, grained illustration board, a medium well suited to this tree-dwelling animal's dense coat of tightly packed, downy tufts. 184 × 317mm (7¼ × 12½in).*

In contrast to a squirrel's, the koala's fur is more akin to that of a sheep's fleece, with very little definition of individual hairs, except around the tufted ears. With this thick covering, it strongly resembles the traditional 'teddy bear' with which it is often compared, though it is not related to the bear family.

HANDS, PAWS OR FEET?

Its front feet are specifically designed for grasping eucalyptus leaves – its only food. There are five toes, of which the innermost two are opposable, like two thumbs.

The forefeet, or front paws, of the Giant Panda, who also maintains a strict diet almost entirely composed of bamboo, are similarly adapted. Besides the five clawed digits, there is a sixth appendage, which is in reality a prominent bone covered with a protective pad, and is quite as effective a device as the koala's two 'thumbs' for grasping, as well as being suited to more delicate tasks. One zoo resident has often been observed daintily feeding herself soup with a spoon!

Above: *pen and ink drawing of the underside of a Giant Panda's intricate and highly adaptable forefoot. Reduced to one half size of original.*

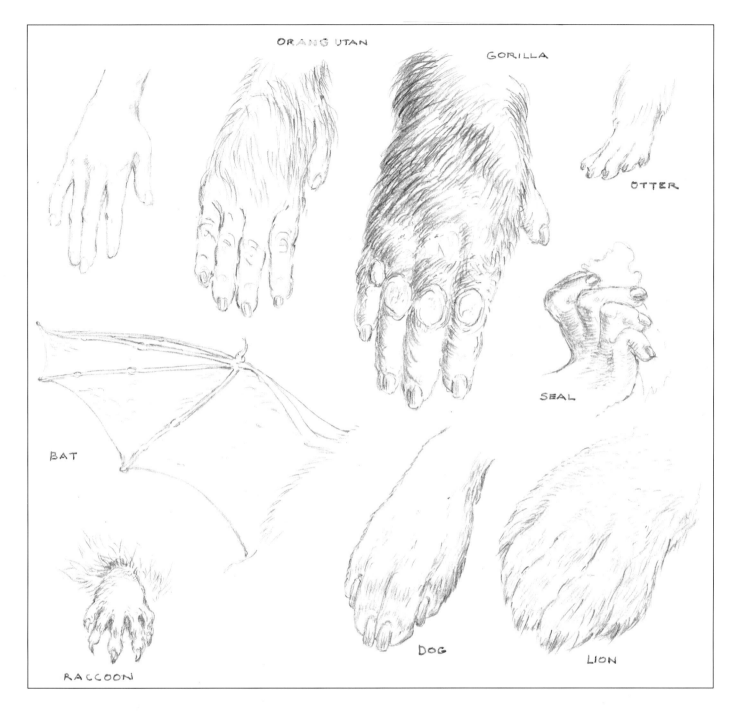

ORANG UTAN

GORILLA

OTTER

BAT

SEAL

RACCOON

DOG

LION

Hands, Paws or Feet? *Primate's compared with others.*

In between the seven pads grow mats of tough hair, not only as protection against rough edges, but also to prevent slipping on ice and snow.

If we can equate the anatomy of animals with our own, it is often easier to understand. These drawings of the 'hands' of diverse species, using gestures with which we can identify, demonstrate this theory as well as showing differences in construction. They are drawn roughly to scale; the dog's paw belonging to a Great Dane, one of the largest canines, is comparable in size to that of the lion, one of the largest felines. Both of these are shown in repose when their position tends to be more like a human hand. The seal's, although its toes (or 'fingers') are webbed, more closely resembles it when clasping its food.

The bat's wing also becomes more readily understandable when regarded as a hand – its four fingers being joined by a large membrane with the hook at the top corresponding to a thumb.

143

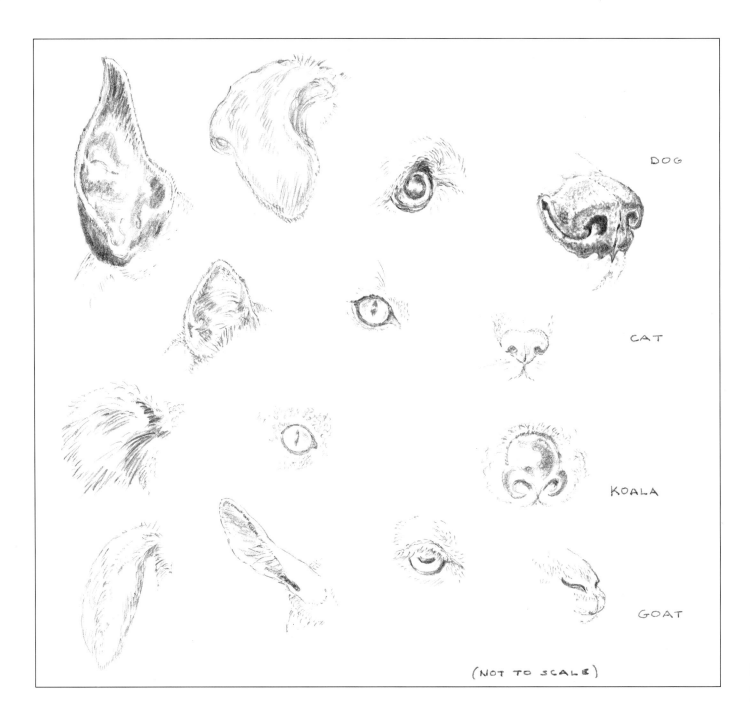

DOG

CAT

KOALA

GOAT

(NOT TO SCALE)

Ears, Eyes and Noses. *The intricacies of these anatomical features merit careful study, especially the dog's nose. This highly sensitive and efficient investigative instrument is far more complex than would at first appear.*

THE SENSORY ORGANS

A Great Dane's ears, like those of the Dobermann, Boxer and a few other breeds, are customarily cropped to a point, except in Britain where this is prohibited. As their appearance is very much altered by this practice, both types are shown here. I have selected some other species as well, whose ears, eyes or nose differ markedly and are especially individual to them. For example: the shape of the pupils in the eyes of the domestic cat and the koala are both vertical slits whereas sheep and goat's are horizontal. The ears of the Nubian goat are particularly unusual, and their pendulous form is thought to protect them from the desert sand. The more conventional goat's ear is shown next to it.

The beak-like nose of the koala is certainly unique, as are its pouched cheeks and odd feet!

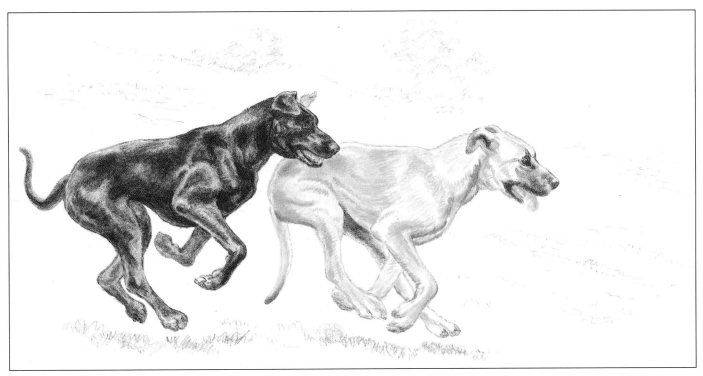

Just for Fun. *Two-colour pencil drawing of a pair of Great Danes. Note that subjects are to the left of the composition, leaving space ahead into which they can run. 115 × 230mm (4½ × 9in). Right: the main bones of the front leg and shoulder whilst running.*

ACTION

These pony-sized dogs were given free rein in open parkland where they raced each other in a huge circular route. Fortunately, they repeated the performance many times, so that I could anticipate their reappearance at a particular spot and study them as they flew past. I was able to get one snapshot and this, together with a good deal of observation and lightning sketches, made it possible to get an impression of their movement.

The action of muscles creates interesting folds in the skin, particularly on the shoulders and haunches. There are not many seconds when the paws seem to touch the ground, so I have drawn them with all eight in mid-air above a blurred shadow to heighten the effect of speed.

On the following page, the movement of the escaping swan is emphasized by the tension in its pursuers as it beats its powerful wings, preparing for flight.

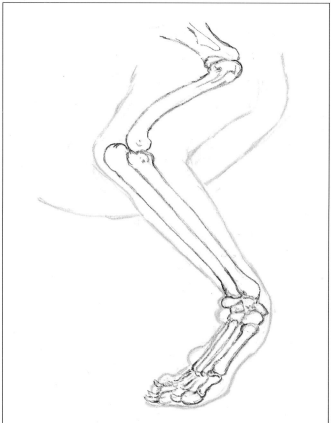

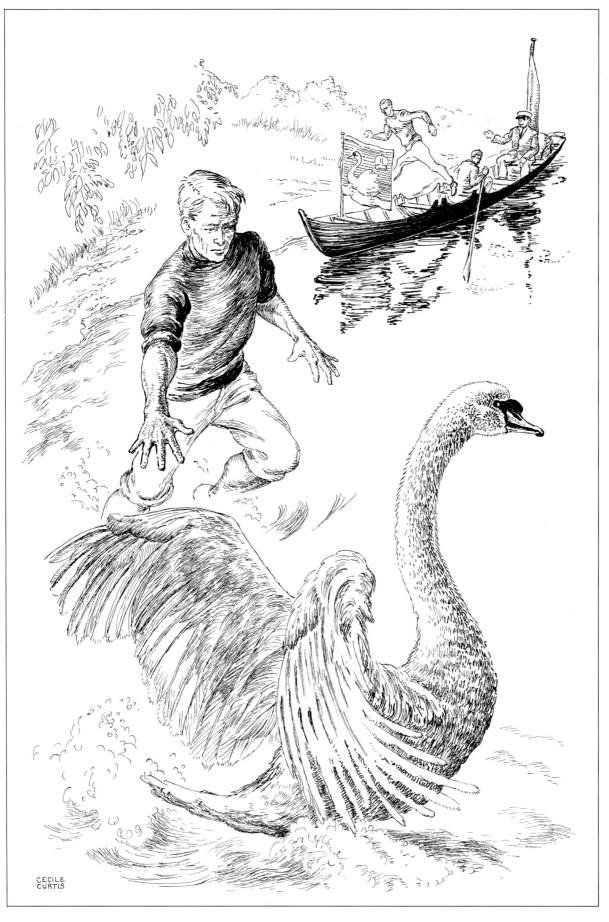

CECILE
CURTIS

At the annual 'swan upping' ceremony on the River Thames there is plenty of action from both human and feathered participants. Pen and ink, 170 × 240mm (9¾ × 6½in).

Spanish Lynx in two-colour pencil. The expression speaks for itself! 227 × 334mm (9 × 12¼in).

FOURTEEN
EXPRESSIONS

THE PRIMATE FACE

The question I am most frequently asked is, how I get expressions in animals – there is no simple answer. It is partly a strong feeling of sympathy, combined with a mixture of observation and intuition. Basically, you have to *look* for it and analyse the ways in which an animal expresses the way it feels. Although we cannot generally translate the moods evident in the human face into the same physical manifestations in other species, there are some parallels. These are most obvious in that of the primates, who also differ from each other as much as ourselves. It is a mistake, however, to equate them too literally. For instance, the broad, toothy grin of an ape indicates anger or aggression as do tightly pursed lips in a straight line.

147

The eyes, as in humans are especially expressive. In the study of an orang-utan opposite, they are its most important feature, invoking a sympathetic response in even the less compassionate of spectators.

This species among the rare 'great apes' has always fascinated me. Its exceedingly mobile facial muscles enable it to 'make faces' with an even greater repertoire than man's, and the youngsters especially, just like naughty children, exploit this facility to great extent with all sorts of grimaces, pouting and forming their lips into a tube even more pronounced than a howler monkey's at full cry.

They have been described as the engineers of the animal world, and any sort of technical equipment is irresistible to them. At a rehabilitation centre in Sumatra, a would-be 'carpenter' learned to handle a saw and plane after watching some builders. The mysteries of any kind of door fastening or lock are soon probed by this seemingly slow and ponderous creature. A famous resident at San Diego Zoo escaped from his cage nightly, with the foresight to push all his treasured toys through the bars first! I was once privileged to see such resourcefulness at first hand.

MEETING THE 'MAN-OF-THE-FOREST'

In this instance, she was a 'lady', but she soon taught me just how ingenious an orang can be. I had been working for some weeks at London Zoo for a children's story I was writing and illustrating on the subject, and had become friendly with the head custodian of this appealing animal. I was delighted when he arranged to introduce me to one of the adult females.

When he unlocked the door of her cage, I did not know quite what to expect as I waited in the narrow corridor behind it. There was deep snow outside, and as I stood there in my nylon fur coat and lined boots, sweltering in the tropical heat of the Ape House, I thought 'Tuli' must have recognized a kindred soul as she came lumbering toward me. Instantly she flung one incredibly long arm around my shoulder, nuzzling me with her soft lips. In one hand I clutched a shopping bag containing an ornate pair of stiletto-heeled shoes in anticipation of dining out with my husband that evening. I was suddenly aware that the long arm had delved into it and in a flash, she had one shoe in her mouth, daintily nibbling at the heel. I tried persuasively to wrest it from her but, despite the seeming frailty of her arm, her strength was far greater than the strongest man. The keeper reassured me, saying he would soon get it back – which indeed he did, by handing her his bunch of keys. With amazing speed, she found the right one and deftly turned it in the padlock. He explained that all the keepers have to be very careful not to have these plucked from their pockets as they pass by!

Following this memorable encounter, I was able to study her as well as her neighbour, a fine young male specimen, through the thick plate glass on the other side, making sketches in preparation for this portrait.

After my experience with this charming pick-pocket, my expensive party shoes were never quite the same again, but it didn't seem to matter somehow. I would much rather have met 'Tuli'.

Portrait of an orang-utan. The original was done in scraperboard using a special technique of mixing black ink with four different coloured inks which initially look black, but when partially scraped out, leave a soft tint of the colour. 483 × 356mm (19 × 14in).

CÉCILE
CURTIS

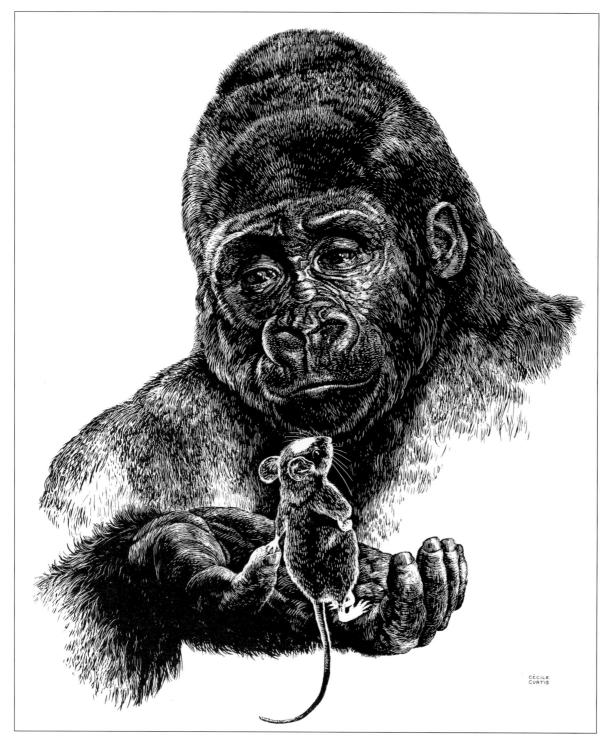

CÉCILE
CURTIS

There can be no mistaking the tender regard in the eyes of the gorilla above, with their moist look and the raised brows, slightly knit, as though in wonderment at the small, strange creature in its palm. The lips, although firmly closed, indicate a relaxed feeling by a gentle turning up at the corners.

The full-colour version opposite, of a mountain gorilla in its lofty habitat shows a subtle variation in its expression. This is a mature silver-back, patriarch and guardian of his troupe. The eyes and mouth immediately indicate a cautious vigilance, as does the lowered brow and alert, direct gaze of the eyes. The lower lip is also prominent, suggesting a firmer set to the jaw. Once these magnificent creatures inspired only fear in man but now, closer human contact with them has proved they are really just gentle giants.

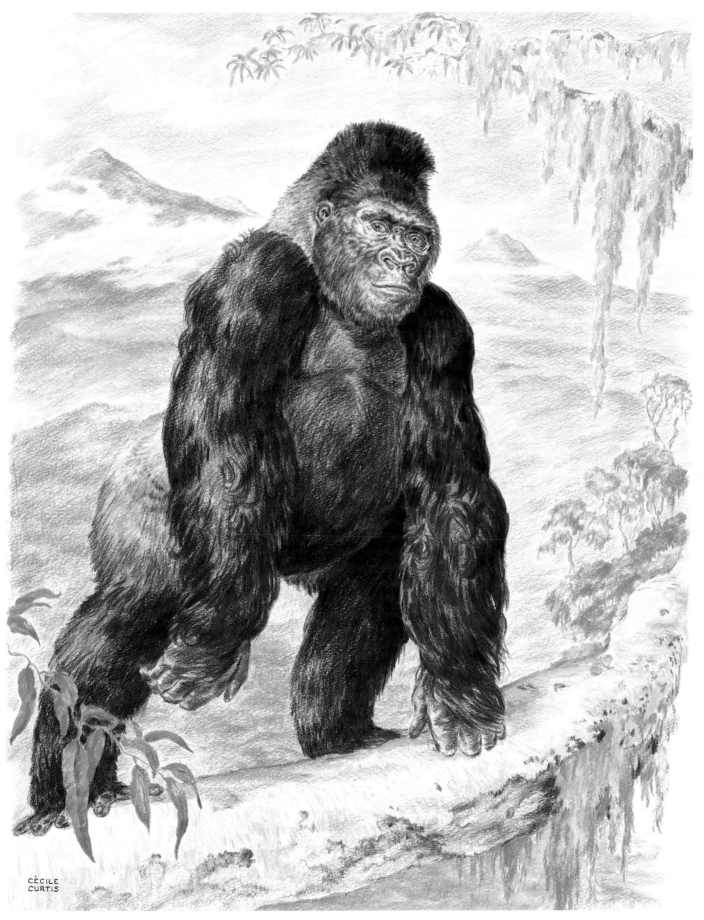

CÉCILE
CURTIS

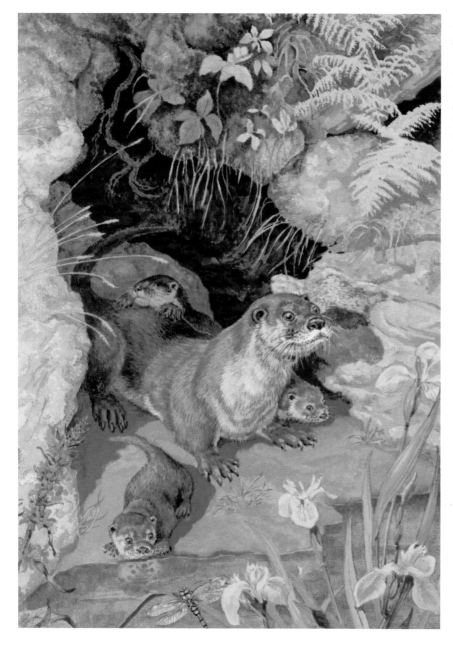

Left: Otter family general greetings card. Gouache/watercolour on white illustration board, 350 × 220mm (12 × 8½in). Right: Part of a jacket design. Elephant in two-colour pencil on white illustration board. Half the size of original.

This greetings card demanded careful research, as much for the painting of the otter's holt as for its occupants. As well as dedication to details of their surroundings, once again, the animals' expressions were an important factor. The bitch otter's is bright and assured as she leads her cubs for the first time from the warm protection of their dark home to the river bank. Her three cubs show in turn, reluctance, caution and astonishment on their journey of exploration. This required a study of numerous photographs and films, adapting the various positions to work well together in the composition. I decided to show the sunlight's direction from the left to provide a cast shadow behind the white parts of the mother's face and that of the cub pressed against her side.

The otter's fur possesses the same principle of protective coloration as many other species, being dark on top with light underparts and useful when in the water, presenting a less obvious silhouette above the fish on which they feed.

Although not the most obvious in its expressions of various moods, this elephant (right) does give the impression of a cheerfully defiant attitude in the carriage of head, trunk and its open mouth. The long, sparse eyelashes and hairs on the forehead and lips give it character. I drew it with a dark blue-grey pencil and filled in the background solidly with a yellow pencil afterward.

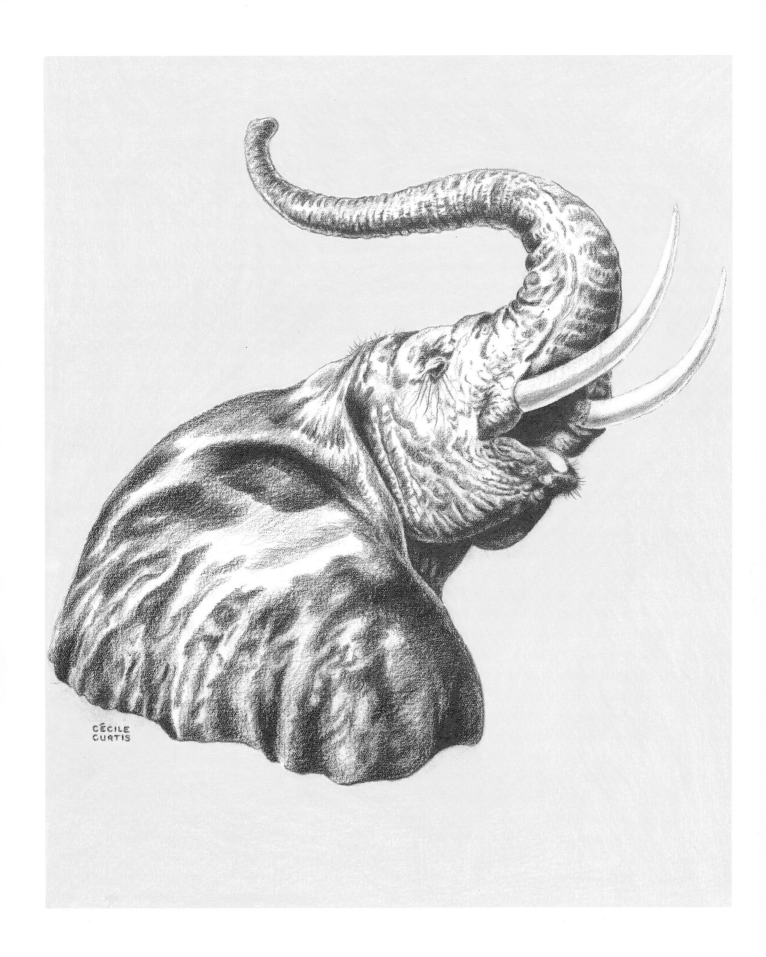

THE CANINE FACE

In seeking to interpet animals' expressions, there are times when actual or induced situations suggest a specific mood. The line of dogs in an obedience class is a typical example. Something unexpected has occurred, and each dog's reaction to it is seen in the attitude of the head or direction of the eyes. The exception, of course, is the Old English Sheepdog where one just has to *imagine* that his attention is on the truant Great Dane! A look of disapproval from the Rottweiler is emphasized by the naturally lighter patches on the brows which suggest a scowl. The odd one out is the mongrel on the right, his steadfast gaze fixed on an unseen owner.

The eye is drawn to the errant Dane by having this figure appear to come out of the light brown shape in which the others are enclosed. The German Shepherd does so as well but, as he is placed in a position well away from the centre of interest, it merely acts as a device to bring him to the foreground, giving the composition a greater sense of perspective. Although the face is only partially visible, it still conveys an attentive attitude, with the body twisted around and ears characteristically alert.

Detail is necessarily limited in the more distant dogs and with their disparity in size or paler colouring. Using a basic range of only three colours plus white, one can nevertheless vary the fur. I applied the gouache quite thickly on the two dogs in the foreground, and introduced coloured pencils for variation on top of the paint. When most of the figures need to be quite small, it is better to depict

Obedience Class. *Illustration in gouache on fawn-coloured board, 305 × 500mm (12 × 21in) for a children's book. The white outline of the free-form was sprayed over the board after being masked out. This eliminated irrelevant background and gave unity to the vignette.*

them wih a very simple technique and caricature expressions slightly. Despite these limitations, one can still express an idea quite effectively on a reduced scale.

The methods involved in capturing the right expression apply equally to wild and domestic species. It can be the essential aspect of a picture and is certainly the most elusive element during its creation. A minute alteration, either intentionally or by accident, can mean success or failure. When you think you've caught the right expression, make sure you don't lose it.

In the painting of three dogs, their expressions were of paramount significance, as I wanted to create maximum support for a worthy dog-welfare charity. Primarily I tried to convey a look of wistful expectancy, as though they were listening for, rather than hearing, the arrival of the Giver of Gifts. The effect of brows raised at their inner corners seemed to convey this feeling, although I redid the faces several times before I was satisfied.

As he had become my 'trademark', I once again used my black Great Dane for a model, providing him with a Bearded Collie and Basset Hound for

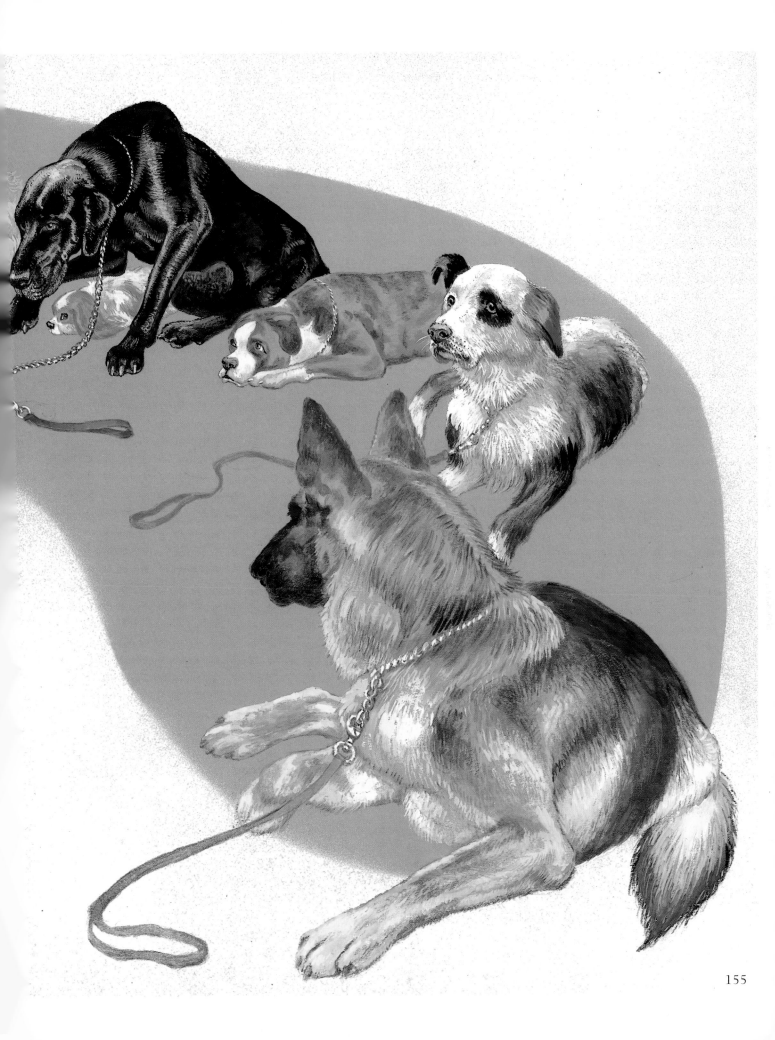

companions. The choice of fawn-coloured board as a background sets off the bright reds and greens as well as blending with the colouring of the two smaller dogs. I used a strong mixture of ultramarine with white to highlight the Great Dane's shiny coat as it would be noticeably neutralized by the background colour coming through, whilst lending variation to the tones in the black fur.

The objects on the mantlepiece, appropriately-sized stockings and the 'fire-dog', are essential components, but I felt that, although it might have looked 'cosier', it was important to avoid distracting clutter of furnishings behind the figures.

A CARD BECOMES A TOWEL

I was very gratified when the design sold well as a Christmas card, and later on when a manufacturer of tea towels wanted to include it in a range of animal and bird designs.

The usual 'half-tone' method of printing needed greater elaboration to reproduce it on material. The basic, three-colour separations of red, blue and yellow – the intermixing of which will produce all the colours of the spectrum – are normally employed in full-colour reproduction. In this instance, however, these also had to be separated into tonal areas, which meant using as many as eight different screens to achieve the results seen here. Slight adjustments were necessary in the values of the brown curtains and shadows on the floor as well as the light around the candle's flames, but these do not really detract from the original design.

SUMMATION

I have tried to elucidate not only my particular approach to drawing and painting animals, but also my reasons for doing so – which include the odd, the unexpected, as well as the more obviously appealing subjects that have especially attracted me. They have provided me with a life-long interest and also a constant challenge: experimentation with different techniques – a striving for yet more lifelike representation and even better ways of conveying the humour and delight which they impart to me. I hope that the reader will have derived some of this from these pages.

Above: *The tea-towel reproduced from the original painting* opposite: Waiting for Santa *Christmas card design 425 × 305mm (16¾ × 12in). Gouache/watercolour and coloured pencil on fawn board.*

I can only urge you to look, observe, learn, and look again. Even the most familiar of household pets can constantly reveal new and ever more interesting aspects of their behaviour and physical attributes. This sense of discovery is perhaps best summed up in these simple lines:

> 'I think I could turn and live with animals. They are so placid and self-contain'd. I stand and look at them long and long.'
> Walt Whitman *Song of Myself*

SOME WORTHY CAUSES

Assuming you are the sort of person who enjoys the enormous pleasures to be obtained from the company of animals and perhaps the satisfaction of presenting them in visual form, why not give them something in return? Here are a few specialist organizations devoted to their welfare and conservation who are all registered charities. They would very much appreciate your help and support.

NATIONAL CANINE DEFENCE LEAGUE (see pp 65 & 154)

Mrs Clarissa Baldwin, Secretary and Chief Executive. 1 Pratt Mews, London, NW1 OAD (Tel. 071-388-0137). Operates thirteen rescue centres throughout Britain where stray, abandoned and unwanted dogs are looked after until new and suitable homes can be found. No healthy dog is ever destroyed. The NCDL seeks to reduce the number of strays by supplying discs (free to members) with a veterinary guarantee should the pet be injured.

It campaigns ceaselessly at national and local levels for improvement in legislation affecting canine welfare and dog ownership. Funds are needed so that more centres can be opened to deal with the ever-increasing number of cast out pets.

NATIONAL FEDERATION OF CITY FARMS (see p 83)

City Farm, The Old Vicarage, 66 Fraser Street, Windmill Hill, Bedminster, Bristol, BS3 4LY. (Tel. 0272-660663). A City Farm is an educational and recreational project run by local communities using derelict land. It provides services for the elderly, the handicapped, teenagers, adults and children alike, offering opportunities for training, education, work and play and encouraging active participation in the care of animals and plants. It also engenders an appreciation through contact with farm animals which many may never have seen at close range.

Practical as well as financial help is needed and volunteers are welcomed. Their headquarters will be pleased to provide the address of one nearest you.

ROYAL SOCIETY FOR NATURE CONSERVATION (see p 94)

The Green, Nettleham, Lincoln LN2 2NR. (Tel: (0522) 752326). The Royal Society for Nature Conservation (RSNC), formed in 1912, is the major voluntary organization in Britain concerned with all aspects of wildlife conservation. The Society comprises 48 local Nature Conservation and Wildlife Trusts and over 50 Urban Wildlife Groups throughout the country.

The Royal Society for Nature Conservation (RSNC) and its Trusts not only protect wildlife sites; they also work hard to safeguard rare or endangered animals and plants throughout Britain. They have played a pioneering role in wild plant protection and championed the cause of the otter and badger.

SWAN LIFELINE (see pp 26 & 126)

1 Markway House, Lower Hampton Road, Sunbury on Thames, TW16 5PN. An organization dedicated to promoting greater awareness of the problems facing the mute swan through manmade dangers and loss of habitat. A rescue and treatment service manned by volunteers, backed by expert veterinary care, rescues and cares for birds suffering from lead poisoning, (from the now-banned fishing weights, many of which are still in use or in the environment) and fishing-tackle injuries. They also aid victims of territorial disputes and flying or other accidents.

The organization concentrates its efforts in the Thames Valley area where the problems encountered are among the worst in the country. For rescues, ring Tim Heron, 0753 75894.

In addition, there are Rescue Services for all breeds of dogs. Here are three relating to some of those featured in this book:

OLD ENGLISH SHEEPDOG RESCUE (see pp 62 & 67)

Mrs Jill Harwood, Chief Co-ordinator, The Old Farmhouse, High Hameringham, Horncastle, Lincs. (Tel. Wincebey 0658 88644). This breed suffers from too much popularity, largely due to a certain well known advertisement showing a dog with long, luxuriant fur, immaculately groomed. Inexperienced and naïve new owners find it is not as manageable as its 'cuddly toy' appearance suggests and consequently maltreat it. The rescue service is kept very busy finding new and suitable homes with caring,

responsible owners who are charged only a donation for one of these dogs. Funds to maintain this worthwhile work are very much needed.

NATIONAL GREAT DANE RESCUE (see p 69)

Mrs M A Temple-Smith, Secretary, Jeffcoates, Hempton, Deddington, Oxfordshire. (Tel. 0869-38879). Re-homes Great Danes whose owners can no longer keep them, mainly because of broken marriages or partnerships. Committee members, area reps and willing volunteers carefully check homes for suitability and help to raise much needed funds, as the £50 charged for one of these magnificent, good-natured dogs (£70 if under a year old) is not enough to cover costs. Of course, pedigree papers are never handed on. Kennels are used only when absolutely necessary, most dogs being taken directly from one home to another.

An open membership has recently been instituted with an annual newsletter and costs just £2.00 per year. (Mem. Sec., Rene Dutnall, Le Clay Cottage, 63 Bedford Road, Barton Le Clay, Beds.)

NGRC RETIRED GREYHOUND TRUST (see p 72)

24/28 Oval Road, London NW1 7DA (Tel. 071-267-9256). The Retired Greyhound Trust was established by the National Greyhound Racing club in 1974 to assist owners and trainers to find suitable homes for greyhounds retiring from racing at NGRC licensed courses when their own efforts had been unsuccessful. A greyhound usually retires from racing at 3 to 5 years of age or through injury, lack of pace or interest. Most of its life remains, as its normal lifespan is about 12 years. Greyhounds are docile, affectionate and adaptable dogs and these characteristics make them ideal family pets.

In addition to making donations and supporting charity meetings, assistance is welcomed for fundraising and finding and inspecting homes.

BIBLIOGRAPHY

ETHOLOGY

Borner, Monica, with Bernard Stonehouse. *Urang Utan, Orphans of the Forest*. W H Allen, London, 1979.
Burton, Maurice. *Just Like an Animal*. Dent, 1978.
Dröscher, Vitus B. *The Friendly Beast*. W H Allen, 1970. Scientific Book Club, London.
Goodall, Jane van Lawick. *In the Shadow of Man*. Collins, London, 1971.
Morris, Desmond. *Dog Watching & Cat Watching*. Jonathan Cape, London, 1986.

ANATOMY

Calderon, W. Frank. *Animal Painting & Anatomy*. New Art Library (Second series) London,

SCULPTURE

Konstam, Nigel. *Sculpture, the Art and the Practice*, Collins, London, 1984.
Mills, John W. *The Technique of Sculpture*. B T Batsford, London, 1976.